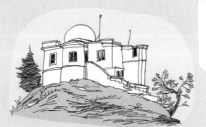

Gonzales

Cook Street Village

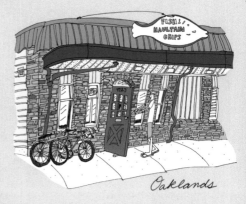

Oaklands

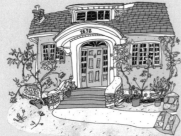

Fairfield

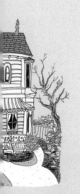

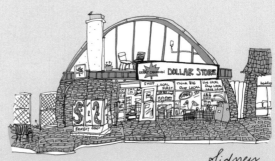

Sidney

Hand Drawn
Victoria

An Illustrated Tour
in and around BC's Capital City

EMMA FITZGERALD

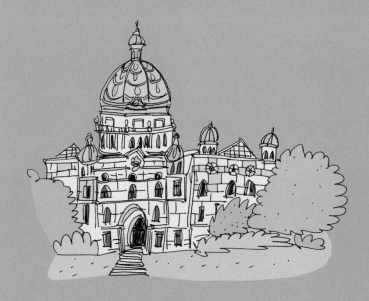

appetite
by RANDOM HOUSE

GORGE WATERWAY

SELKIRK TRESTLE

Butchart gardens & North Saanich & Sidney

HILLSIDE

MUNICIPALITY OF ESQUIMALT

QUADRA VILLAGE

POINT ELLICE

ROCK BAY

BAY STREET

BURNSIDE GORGE

NORTH PARK

the Galloping Goose

VIC WEST

UPPER HARBOUR

CHINATOWN

DOWN TOWN

PANDORA AVE

HARRIS GREEN

ESQUIMALT ROAD

JOHNSON ST BRIDGE

Songhees Walkway

INNER HARBOUR

FORT STREET

FISHERMAN'S WHARF

VICTORIA

JAMES BAY

BEACON HILL PARK

MEEGAN

COOK STREET VILLAGE

COOK STREET

OGDEN POINT

I acknowledge the ləkʷəŋən
(Lekwungen) people, also known as the Songhees and Esquimalt
First Nations, on whose land I completed these sketches.

SPIRAL BEACH

CLOVER POINT

MUNICIPALITY OF SAANICH

UVIC

CADBORO BAY

CADBORO BAY ROAD

OAKLANDS

UPLANDS

ESTEVAN VILLAGE

CATTLE POINT

MUNICIPALITY OF OAK BAY

WILLOWS BEACH

FERNWOOD

JUBILEE

N E W S

OAK BAY AVENUE

ROCKLAND

RICHARDSON STREET

MCNEILL AVE

MOSS ROCK

FAIRFIELD

FOUL BAY RD

GONZALES

BEACH DRIVE

CHINESE CEMETERY

ROSS BAY CEMETERY

DALLAS ROAD

To Hannah Margaret, who made me an auntie while I lay on Willows Beach collecting pebbles.

Salish Sea

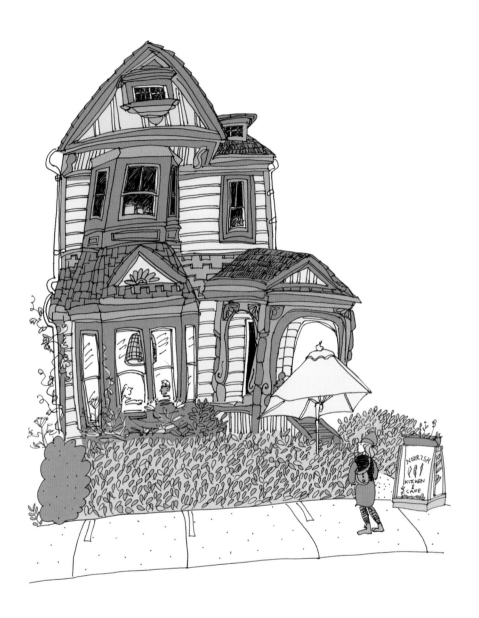

A popular breakfast item at Nourish in James Bay is the Golden Benny:
poached eggs served with a turmeric cashew Hollandaise sauce.

CONTENTS

INTRODUCTION

In March 2020, when I left my home at the time in Halifax, temporarily relocating to Victoria to work on this next book in my Hand Drawn series, I couldn't have known just how much the world was about to change. Before the COVID-19 pandemic hit the country, I had already chosen British Columbia's vibrant capital as the next subject for my collection of sketches and stories. New to the city, after careful self-isolation I walked and biked its streets, sketching on location, and began to notice the quirks and special characteristics of each neighbourhood. I started where I lived in the verdant and stately Rockland neighbourhood just east of downtown. Gradually I increased the circumference of my daily jaunts, until, after my fourteen months in the city, I felt the satisfaction one feels upon completing a puzzle, all the pieces fitting together in my mind's eye.

My only other significant time in Victoria was a two-week summer dance intensive when I was eleven, ferrying over from the mainland. The lasting impression of the city was a British-style sweet shop that sold candies tasting of perfume. Many people have the impression that this is all Victoria is: a candied facsimile of olde England. However, returning as an adult, I found it to be so much more. Not only does its downtown core boast the oldest Chinatown in Canada, a testament to the contributions of new settlers from that country, but the city is also host to independent Mexican, Filipino, and Korean grocers.

Victoria is filled with notable architecture, from the impressive Empress Hotel to charming beach cottages. But the city's flora and fauna became an equal focus for me. Each day held a new discovery: a serpentine spine surfacing on the water (was it a seal or an otter or

maybe a porpoise?) or the jagged, heavy breathing of a sea lion swimming off Clover Point as early risers jogged by on Dallas Road, en route to Beacon Hill Park.

To truly understand Victoria, I went farther afield; the places that rub shoulders with the city are part of its psyche too. Most obvious from a tourist perspective is the Butchart Gardens. By bike, I could easily reach the neighbouring municipalities of Esquimalt and Oak Bay. I joined the local car sharing co-operative and made day trips to North Saanich, Sidney, and the Juan de Fuca Trail. I've collected and organized these sketches and stories in clusters that radiate out from downtown Victoria. They may be out of seasonal order, but are still true to the flavour of each neighbourhood in the way I understand them.

In a year like no other, I had less opportunity to interact directly with people. In some ways, it actually made my job of stopping, observing, and appreciating through the act of drawing feel all the more vital. This book does not seek to focus on the pandemic but rather on the life pulse of the city of Victoria that kept on going in spite of it. The city's ever-improving active transportation, fragrant gardens, beach walks accompanied by friendly head nods, combined with progressive and creative residents ensured there was always something interesting around the corner. You'll find my discoveries in the pages of this book. I hope they serve as a starting point for retelling your own stories and new adventures.

The Songhees Walkway affords a view of downtown Victoria, including the Johnson Street Bridge dotted with commuters, various brick buildings, and a pocket-sized park occupied by teenagers mostly dressed in black.

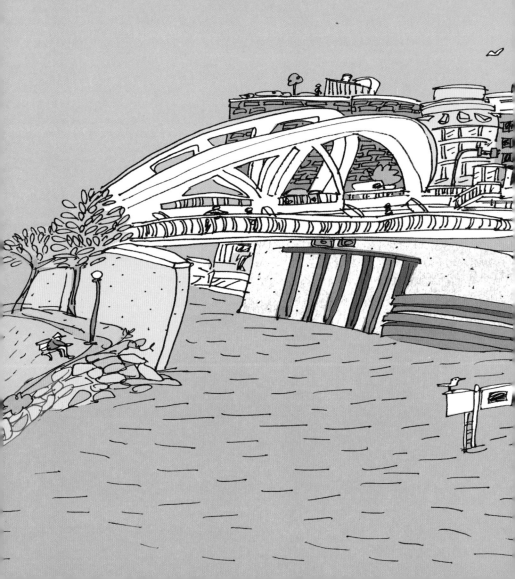

DOWNTOWN

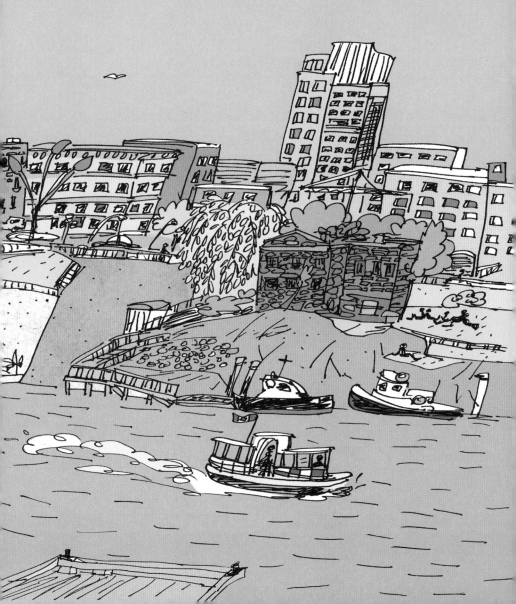

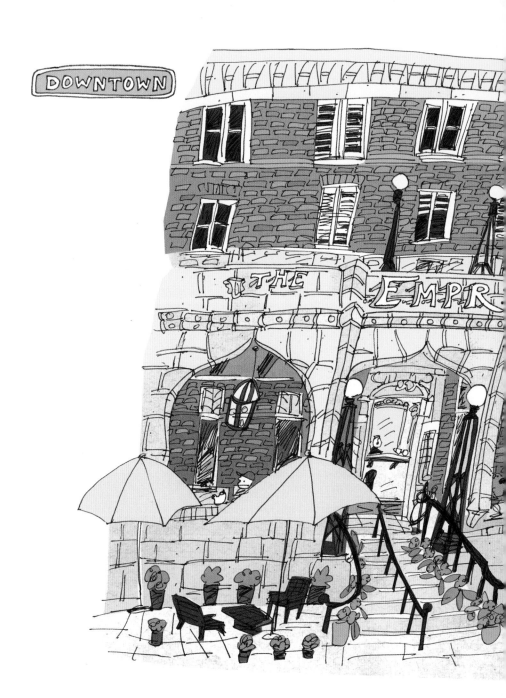

I can't sketch Victoria's charms without including the Empress Hotel, designed by Francis "Ratz" Rattenbury, the same architect responsible for the nearby Parliament Buildings. While I'm sure it would be magical to sleep in one of its 464 rooms, staying overnight isn't the only way to enjoy this grand old hotel. As I sketch its veranda, a steady stream of patrons, including little ones in party dresses (with matching masks), trot inside for afternoon tea. As well as the hotel's classic tea service, there is also a new "tea to go" option, featuring iced tea made with the Empress's signature orange pekoe blend and a box of treats ready for a picnic.

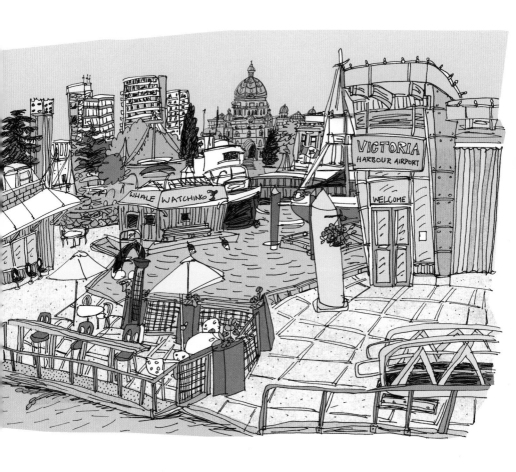

Within minutes of taking off in a Harbour Air seaplane from Victoria's Inner Harbour, I trace my daily walk along Dallas Road from the sky, searching the waters below for a possible orca sighting. In less than an hour, I find myself in downtown Vancouver's hustle and bustle, as close to a sense of teleportation as I am ever likely to feel.

On weekends and holidays from April through October, starting at 10:45 a.m., the water taxis that normally transport people around the harbour put on a synchronized performance set to classical music in front of the Parliament Buildings. Murray Boyce, who has his back to me while I sketch, has been the sound technician for the "Water Ballet" for twenty-nine years, in addition to his job setting up sound equipment for the City of Victoria. He tells me the boats were originally made for Expo 86 in Vancouver, where the fair's theme was "Transportation and Communication." The water taxi captains, who volunteer their time to perform, generously bring me along on one of their practice runs in the Gorge Waterway. It was a swirling adventure that rivalled any rehearsal in my own short-lived dance career as a young ballet dancer growing up.

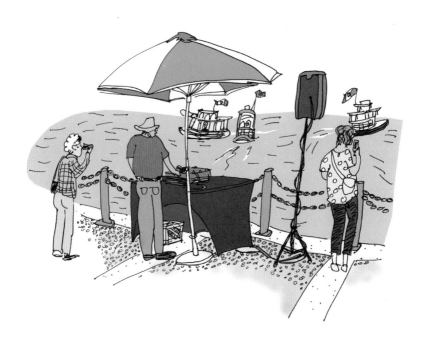

Protests directed at the provincial government to end logging of the remaining 2 per cent of old-growth forests bring together Indigenous leaders, climate scientists, and everyday citizens in front of the BC Legislature's Parliament Buildings. Signs make impassioned pleas as people take their turns in front of the crowd, sharing stories and songs, and cars drive by honking in support.

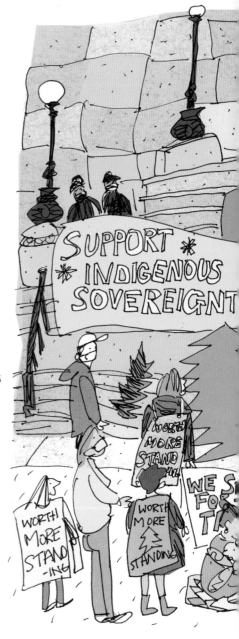

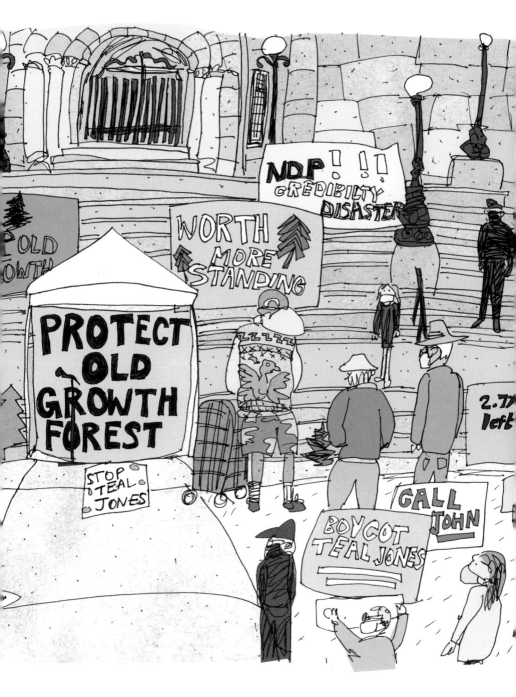

A plate of oysters is a treat on the cozy back patio of Ferris' Grill &
Garden Patio. After going once with a friend, I return by myself, unable
to resist the lure of oysters.

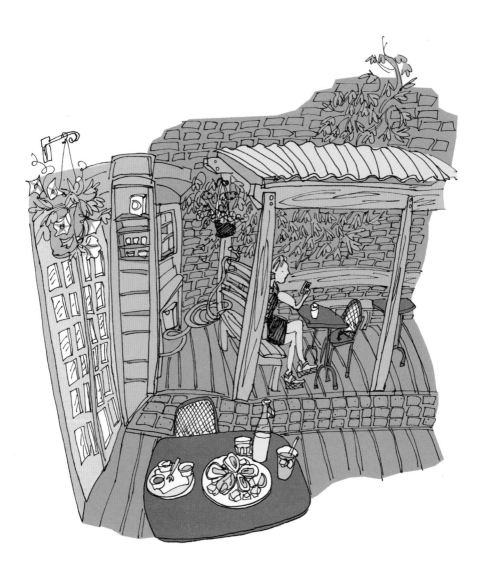

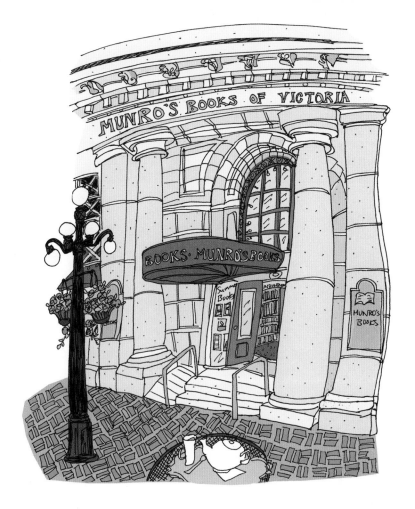

Munro's Books was first opened in 1963 by Alice Munro, the celebrated Nobel Prize-winning author, and her husband, Jim Munro, in a less prestigious location on Yates Street, becoming an important beacon well before moving to its current spot on Government Street in 1984. Now, it's a veritable place of worship for book lovers, offering a great selection of literature in a beautiful heritage building, which was originally built in 1909 as a Royal Bank of Canada. A pot of tea from the Murchie's cafe next door keeps me company as I sketch its facade.

Market Square is a beautiful example of heritage buildings lovingly restored and repurposed. The warm brick courtyard is home to vintage and gift shops, Pacific Rim College, and two breweries that spill into the open space: the Drake Eatery and Whistle Buoy Brewing Company. Discreetly tucked away is Green Cuisine, which is popular with students for its vegan food with buffet, sit-down, or takeaway options. As this Yelp review from B. H. in Southern California attests, tourists also seek it out:

> My mom and I ate here nearly every single day on our vacation to Victoria years ago, and we STILL rave about it. Their desserts are incredible, and that CORN BREAD!!! We love this place so so much, and we only wish it would come to the United States!!!

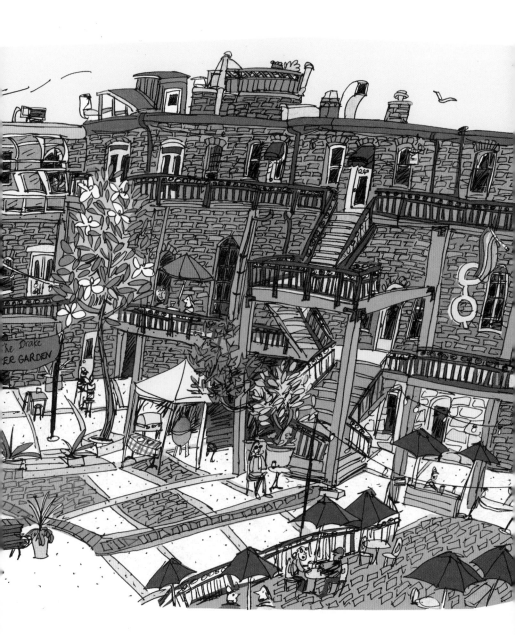

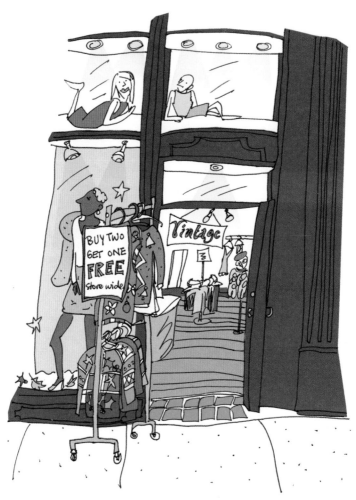

During the 2020 holiday season, I pass vintage store Patch Clothing almost daily on my way to the Canada Post office a couple of doors down. One day I notice there is a two-for-one storewide sale—including "ugly" Christmas sweaters, prompting a smile and a sigh. I am tempted, but decline, as I won't be attending any Christmas parties this particular year.

A server at Shine Cafe clears
the breakfast crowd's plates,
while a cartoon head devours
a reel of film on magenta-
coloured posters plastering
a nearby telephone pole. It
is promoting the Victoria
Film Festival, which will
happen online for the first
time this year. Prompted
by the posters placed
throughout town, I buy a
pass and watch both local
and international films
from the comfort of
my bed, brightening
up dreary February
evenings.

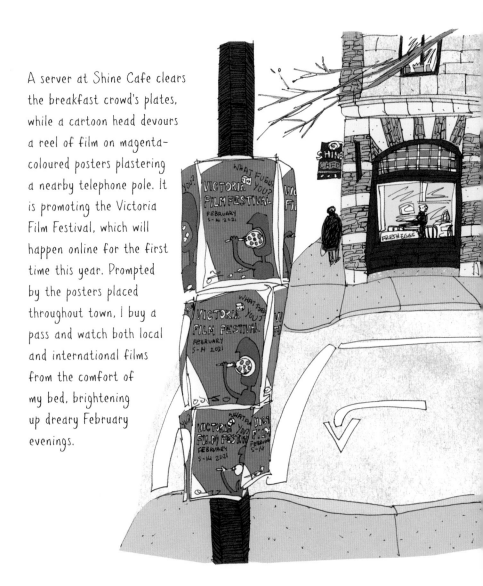

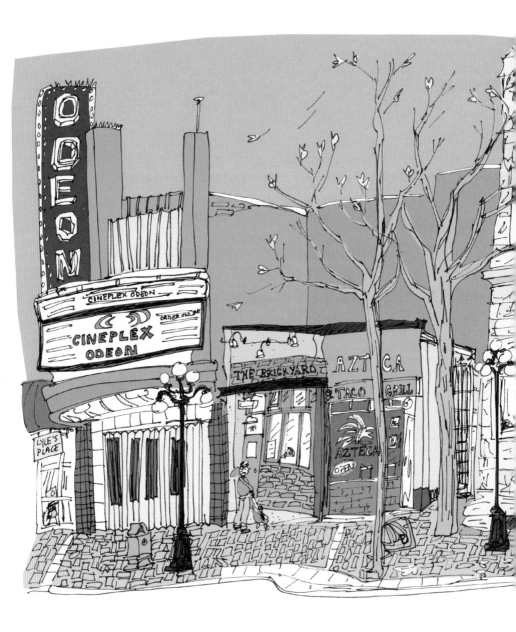

The Cineplex Odeon Theatre and Brickyard Pizza help make for a colourful mishmash of shapes and delicious smells on Yates Street. Popcorn aroma mingles with hot pepperoni slices, stimulating my appetite as I walk home. The neighbouring stately, but slightly forlorn, former Victoria Library is now vacant, with a more sombre feel—a vestige from Andrew Carnegie's grand vision that saw more than 2,500 libraries built around the world in his name from 1883 to 1929.

Olde Towne Shoe Repair on Johnson Street has closed permanently since this summer day when I sit on the sidewalk to sketch it, feeling I just have to make a record of the handwritten signs, one promising "I fix cracked soles." The owner, Mike, says the humour was not intentional, but one can't help but grin or at least smirk on reading it. Smiling is always good for the soul.

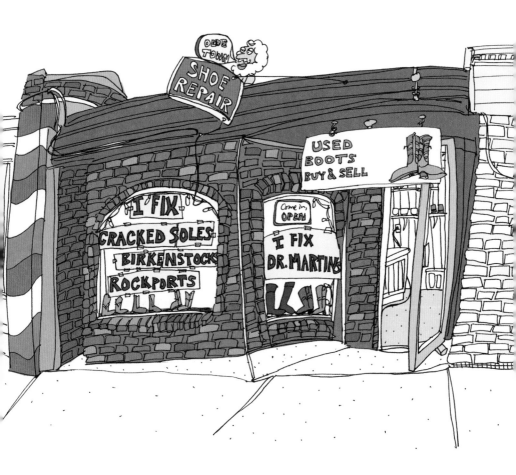

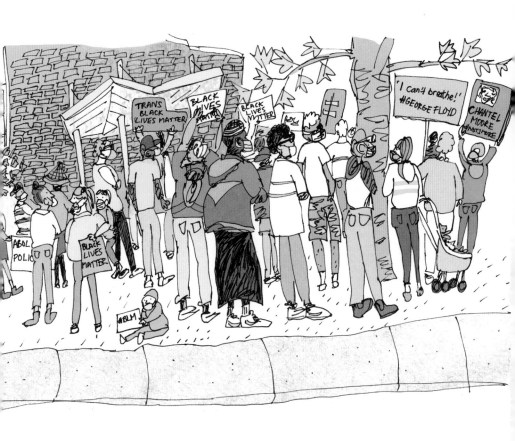

When George Floyd was senselessly murdered by a police officer on May 25, 2020, in the US, people around the world took to the streets in protest, including here in downtown Victoria. Local citizens waved signs in the air at Centennial Square, a large open space tucked behind City Hall, while speakers from various anti-racist organizations enlivened the crowd, urging action and spreading the message: Black Lives Matter.

CHINATOWN & BURNSIDE GORGE

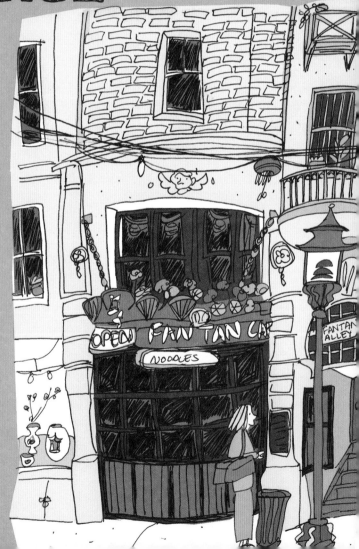

The entrance to Fan Tan Alley in Victoria's Chinatown is almost imperceptible between Fan Tan Café and Cathay Living, but is a gateway to an eclectic medley of shops. Tourists linger along the sidewalk, while some drag queens, including James Insell (a.k.a. Jimbo from the TV show *Canada's Drag Race* and winner of the eighth season of *RuPaul's Drag Race All Stars*) burst onto the street, gone before I can sketch them.

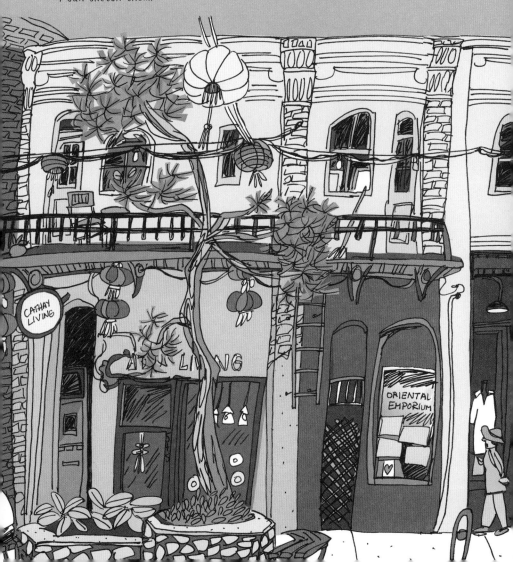

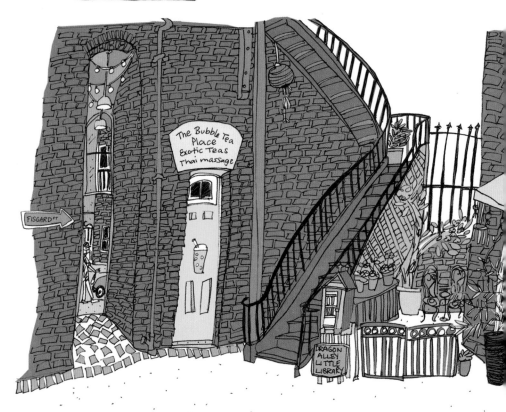

Dragon Alley was part of the initial built environment of Victoria's Chinatown, the oldest in Canada, which began in 1898 with the influx of Chinese workers looking for new opportunities via the Fraser River Gold Rush and the Canadian Pacific Railway. Its series of maze-like alleys would have been witness to daily life—children headed to school, laundry hanging to dry, and also opium dens and gambling. Today I hear chimes carrying sounds on the breeze and notice a Little Free Library.

I hear someone say, "Don't look. Just don't look," to her friend as they pass by the window of La Roux Patisserie on Fisgard Street.

Another pair passes by:

"Oh they look so fancy; let's go have something!"

"Don't we have to go?"

"Nah, I just put another hour in the parking meter."

Atop the glass display cases, white cardboard boxes await your selection from the daily offerings:

Eclair

Paris-Brest

Italian Orange Cake

Tarte Citron

Dark Chocolate &
 Passionfruit Tart

Pear & Champagne Cake

Carrot Cake

Blueberry Maple Profiterole

Peanut Butter & Chocolate
 Petit Gâteau

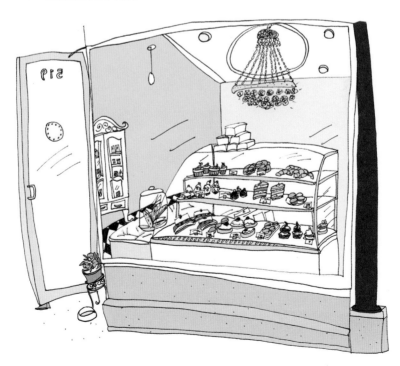

At 636 Fisgard Street stands the Chinese Public School. Built in 1909, it was the result of a 1908 Victoria School Board policy that excluded Chinese children from public schools. This exclusionary policy was one of many measures that prevented Chinese immigrants from being full citizens in the new country they were helping build.

My friend Lauren Chang recalls her family's history with the school: "My grandma Eva Wong (nee Chung) was born and raised in Victoria's Chinatown, where her father, Chung Ham, had settled in 1897, eventually running his own tailor shop, Kam Lum Tailors, despite having no formal education. When it came time for Eva and her siblings to go to school, he did not want them attending the Chinese Public School, knowing they would not learn to

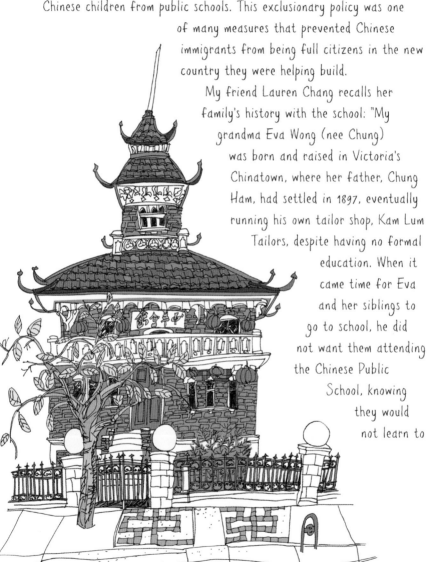

speak English as well, if at all. He had an acquaintance who lived in a predominantly white, middle-class neighbourhood and allowed Chung Ham to pretend it was his own residence in order to be in the catchment for the now demolished Spring Ridge School, located in Victoria's Fernwood neighbourhood. Chung Ham knew that by attending school there, his children would become fluent in English. However, it was not an easy decision for the family. To give the appearance that they lived in the neighbourhood, Eva's father learned how to drive and bought a car. He would bring lunch to them, which they would eat in the car around the block from the school, as most of the children walked home for lunch. In addition to these logistical complications, Eva and her siblings faced much discrimination because of their Chinese heritage. Students would poke fun at them and teachers would yell and hit them on the head when they couldn't understand something because of their limited English comprehension.

"Eva went on to have a career as a nurse and later became a flight attendant and mother, and her siblings (all eight of them) also went on to build successful careers, families, and lives for themselves. Notably, her brother Wallace received the Order of Canada for his contributions to the community as a cardiovascular surgeon but also as a historian and a collector. He amassed more than 25,000 items over sixty years related to early British Columbia history, immigration, and settlement—particularly of Chinese people in North America—and the Canadian Pacific Railway Company, many of which are now housed in a permanent collection at the University of British Columbia."

BURNSIDE GORGE

As I sketch this rusted metal octopus found on a gate at Capital Iron, a garden/home maintenance/outdoor shop housed in a series of historic buildings in Burnside Gorge, a steady stream of people with bags full of finds from the Value Village just up the block pass by, some pausing to notice the gate. I wonder if the gate will remain when Capital Iron closes its doors. It would be an appropriate tribute, as nearly 90 years ago the still family-owned company began as Capital Iron & Metal Ltd., selling scrap metal.

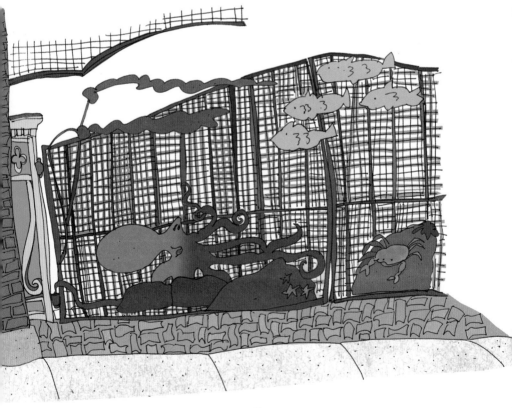

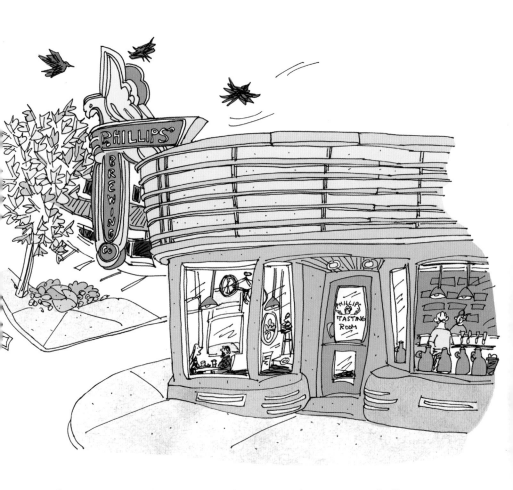

Several crows circle the neon eagle that signals the current Phillips
Brewing's shop/brewery/tasting room located on Government Street as it
nears Rock Bay, not unlike the crows that circle real eagles, something
I often see on evening walks in Beacon Hill Park on the far side of town.
Phillips Brewing has had a few locations since it began in 2001, but all
the while it has focused on making delicious craft beer.

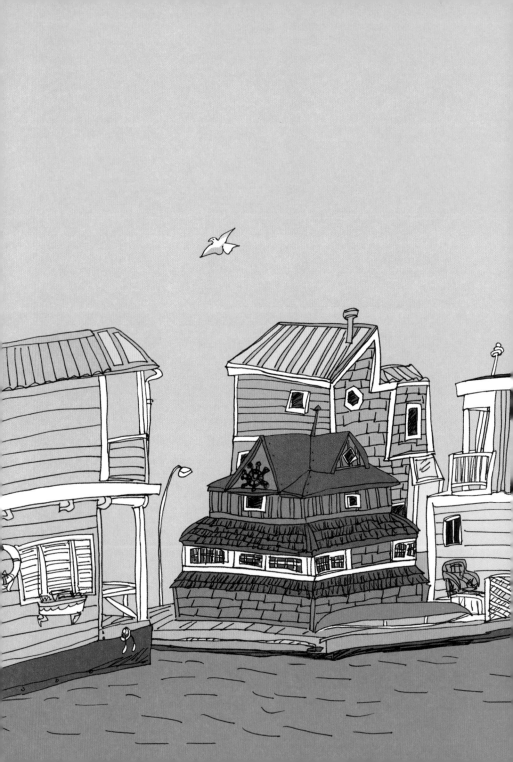

JAMES BAY, BEACON HILL PARK & COOK STREET VILLAGE

Located within James Bay, the floating homes of Fisherman's Wharf are among the most unique properties in Victoria. Instead of the typical backyard raccoons and skunks, residents are visited by otters, seals, and other ocean creatures.

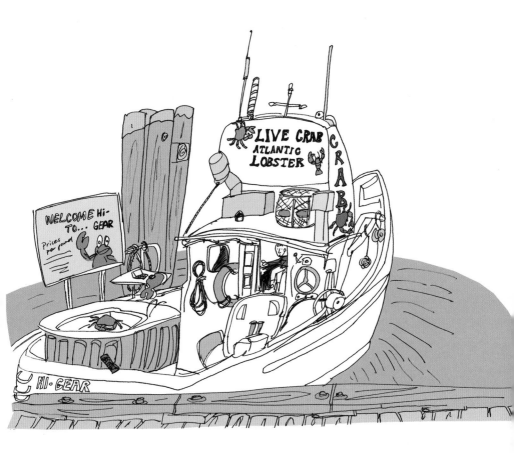

A fishing boat cum fish shop, Hi-Gear Seafood, sells Dungeness crabs and Atlantic lobsters directly to passersby on the Fisherman's Wharf boardwalk.

One way to get to James Bay from downtown is to grab a yellow water taxi in front of the Parliament Buildings and head to Fisherman's Wharf. Once you arrive, walk past the eclectic houseboats and across the green expanse of Fisherman's Wharf Park to Finest at Sea. Housed in a shingled dwelling painted green, it is a great place to grab delicious seafood tacos from the food truck out front or some candied salmon from the fish shop around back.

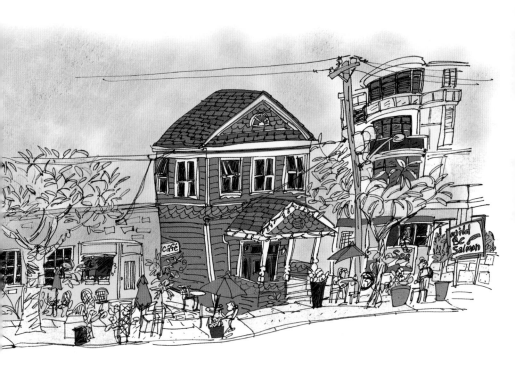

The Birdcage Confectionary has operated since 1915, making it the oldest corner store in Victoria. According to an employee, it was named after the stretch of Government Street it sits on, which used to be referred to as "the Birdcage walk" because of the abundance of birdcages in the neighbourhood homes and the nearby Parliament Buildings' domes that echoed their rounded shapes. The store was constructed for its first owner, Kleanthes "Pete" Metro, for $400. Originally from Greece, he led a seafaring life before settling in Victoria, living next door at 503 Government Street and renting out the shop.

Today, it is not just a corner store; it also sells house-made chocolates alongside flowers, gum, and newspapers.

I see a neighbourhood teen walk by with a pet ferret in their arms, but miss my chance to sketch them. Instead, I turn my focus to the brightly coloured bouquets for sale out front. My friend Leanna's kids, Otis and Russell, get to pick out a bouquet for her each week, as well as a treat for themselves—more often Cheetos or Gatorade, rather than the in-house chocolate offerings.

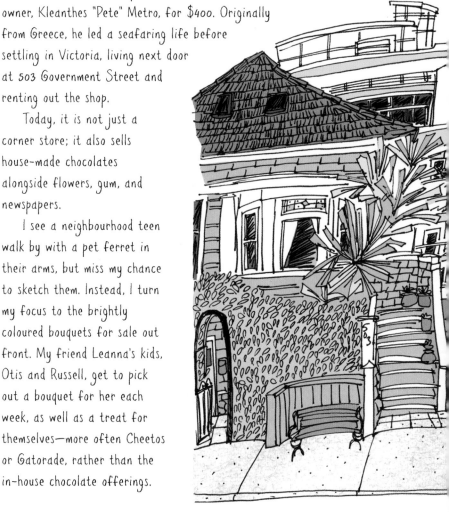

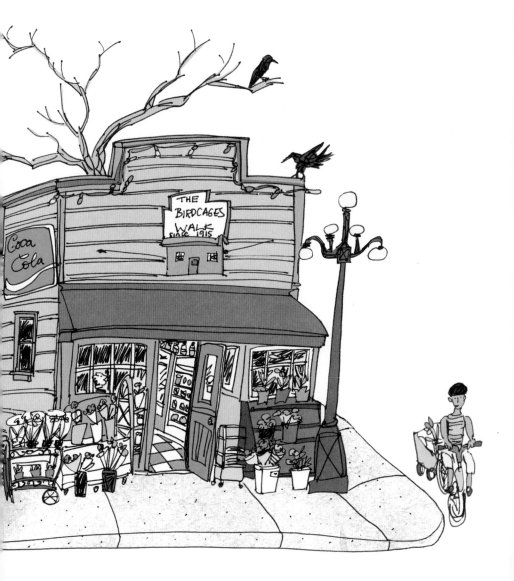

The house at 207 Government Street is the birthplace and childhood home of famed artist Emily Carr. Her lifelong love of nature, often depicted in her paintings, likely began in the back garden among the lush plantings and on visits to nearby Beacon Hill Park. My friend and fellow bicoastal author/illustrator Lauren Soloy, who grew up in Victoria and now lives in Nova Scotia, envisions what that time was like for Emily in a memorable picture book, *When Emily Was Small*, reminding me how my own childhood on the West Coast imprinted itself on my imagination and now finds its way into my drawings.

The Beacon Drive In, a 1950s era diner adjacent to Beacon Hill Park, opened in 1958 and has not changed much since. Its current owner, Peter Loubardeas, boasts that the top ten menu items have been the same for forty years. My favourites are the soft-serve vanilla ice cream, deep-fried oysters, and fish burger, which I enjoy while sitting on a park bench overlooking the ocean.

Any 1950s-era fantasies of first dates spent sharing ice cream sundaes while wearing a poodle skirt are shattered as I hear some teenage boys behind me:

"Hey, I matched with this girl on Tinder! She just messaged me."

"So are you gonna write back?"

"Nah, I don't wanna."

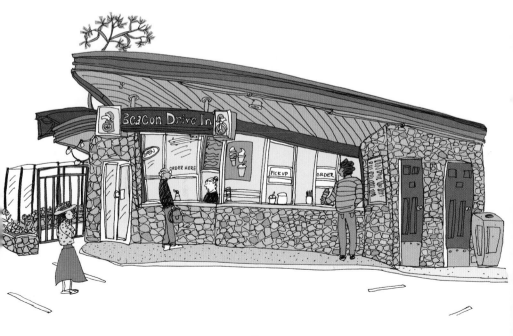

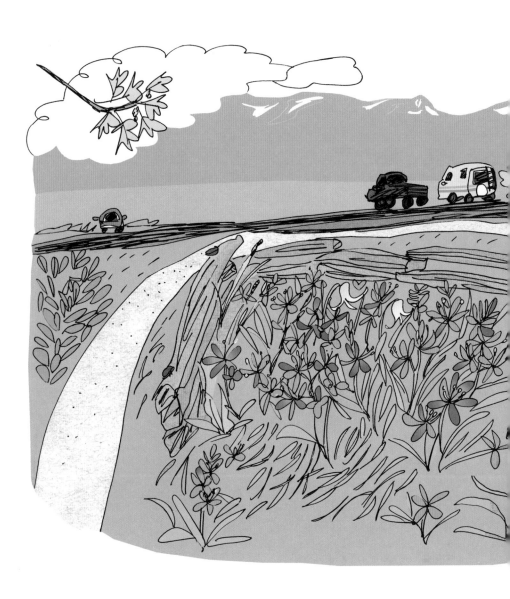

KWETLAL
FOOD SYSTEM

SONGHEES &
ESQUIMALT
TRADITIONAL
TERRITORY

In front of me lies a carpet of blue camas flowers at the edge of Beacon Hill Park, with Dallas Road, the Salish Sea, and Olympic Mountains beyond.

This place is called "Meegan" by the Songhees people, meaning "warmed by the sun." Cheryl Bryce, an Indigenous knowledge keeper who runs Colonial Reality Tours of Victoria, shares her ləkʷəŋən (Lekwungen) culture in a CBC interview:

"It can get pretty windy here but there are some spots as you walk down on the slope that you will find there's just a tunnel of no wind, and you could just lay down and warm your belly in the sun."

Bellies were warmed by not just the sun; the bulbs of the camas flowers served as an important food source and are still eaten today. On the phone with me, Cheryl enthuses about how the flavours differ depending on the cooking method; sometimes she cooks the flower's bulbs with steam in a pit dug into the earth. For her ancestors, it was a valuable item for trade with other Indigenous Nations for prized items like razor clams and oolichan oil. The wooden fence that protects the flowers indicates the protected status of this plant, to ensure it can be enjoyed and used for generations to come.

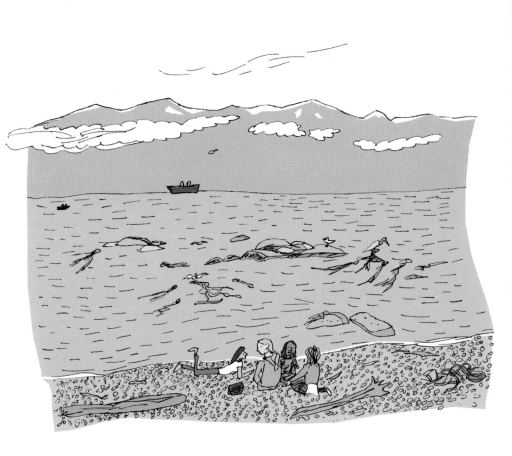

A few days before September and the start of the school year, I spot a group of friends gathered by the shore at Spiral Beach, with the Olympic Mountains across the water before them and the eroding cliffs that edge Dallas Road behind them. They discuss time travel bracelets and the linguistics of another society: "The first word she learned in Dragon was 'snail'!"

As I draw, their mothers sit behind me on logs, discussing dentist appointments, school supplies, and then homelessness. "Lucy calls the needles in the park 'noodles'—I tell her not to touch them, no matter how pretty they are."

In early spring in the wooded area of Beacon Hill Park, I see a pair of owls, a big draw for local photographers who gather at dusk to capture their mating rituals. The clicking cameras and the squawks of peacocks who also inhabit the forest make for a strange soundtrack to my evening walk.

When I return in winter, the owls appear to have left. Instead, I notice orbs fashioned out of branches. They hang from trees like disco balls, minus the mirrors, seemingly waiting for a gathering of fairies in the forest.

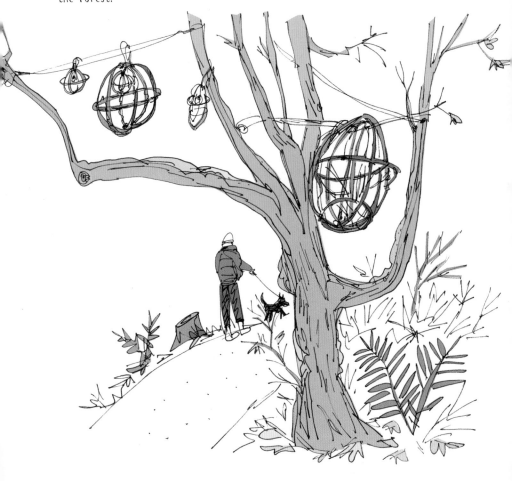

Delicious homestyle fried chicken is only half the story at Thunderbird Korean Fried Chicken. Also worth coming for are the buttermilk biscuits, many house-made dips, and a refreshing apple slaw.

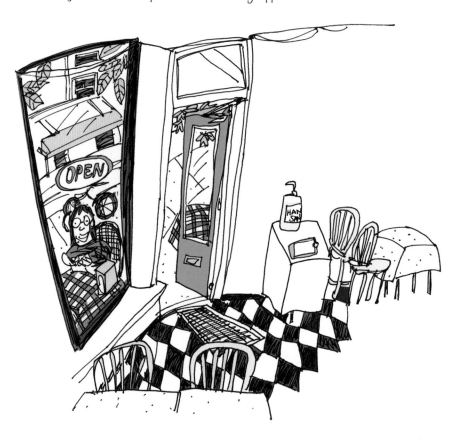

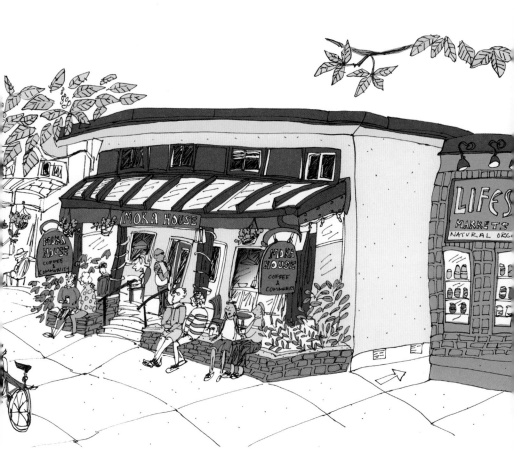

A canopy of chestnut trees adds shade to the glass patio ceiling at the Moka House, where treats and chats can be found together.

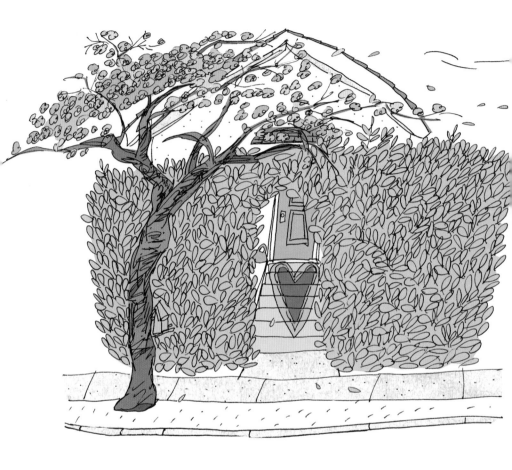

During my first time out sketching in my new environment, these steps painted with a heart and the cherry blossom petals in the wind seem to burst with love; they soothe me. I get so engrossed that I do not hear an elderly woman approaching where I'm perched on my foldable stool on the edge of the sidewalk. "Not very good social distancing," she practically hisses. I sheepishly get out of the way. Then I focus on the heart again, and bring myself back to centre.

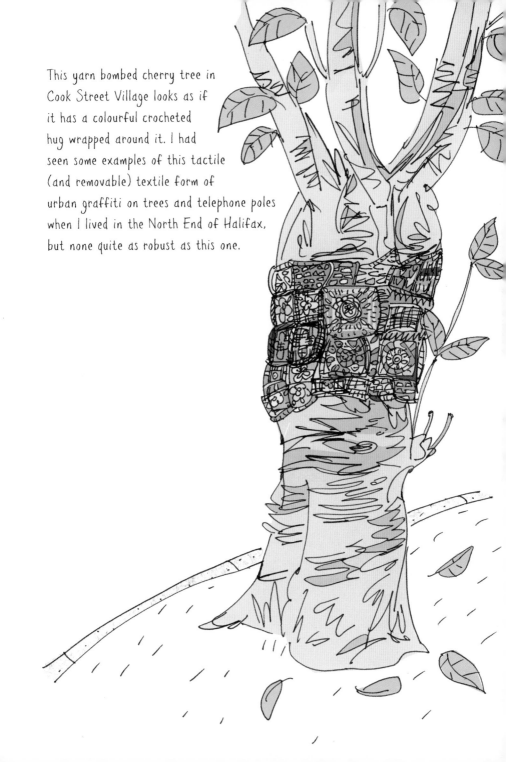

This yarn bombed cherry tree in
Cook Street Village looks as if
it has a colourful crocheted
hug wrapped around it. I had
seen some examples of this tactile
(and removable) textile form of
urban graffiti on trees and telephone poles
when I lived in the North End of Halifax,
but none quite as robust as this one.

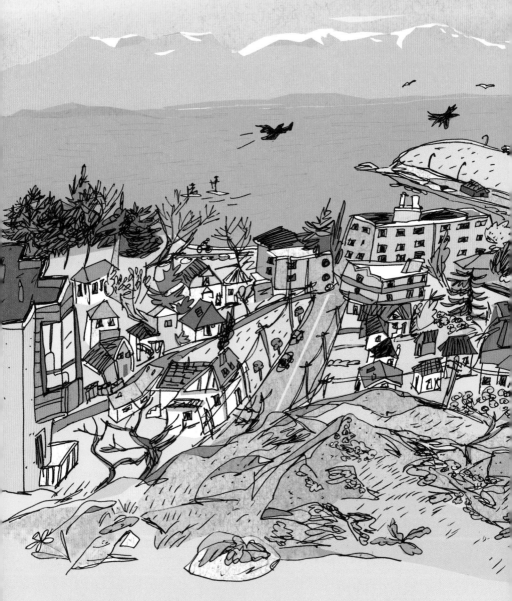

FAIRFIELD &
HARRIS GREEN

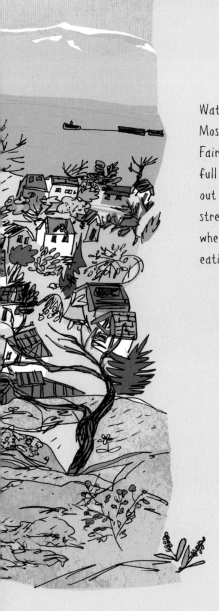

Watching moonrise and sunset atop
Moss Rock is a ritual for many in the
Fairfield neighbourhood. As I wait for a
full moon to appear in the east, I look
out past the cherry blossom-festooned
streets below, toward Clover Point,
where that morning I saw an otter
eating a whole salmon on the rocks.

FAIRFIELD

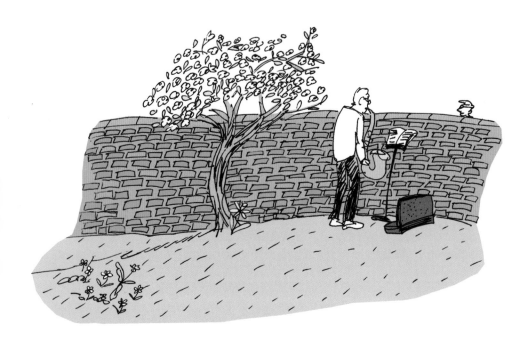

A musician plays the saxophone inside the grounds of St. Ann's Academy.
The apple trees and a patch of daisies and dandelions appear to be his
only audience, until a person's head bobs along the other side of the wall.
The song that wafts through the air, mingling with the heady scent of apple
blossoms, is the Jazz standard "You're Nobody Till Somebody Loves You."

During my second spring in the city, "Save Fairy Creek" signs sprout from lawns across Victoria like mushrooms. This particular protest in front of the law courts is during the serving of an injunction by logging company Teal-Jones against those protesting the logging of old-growth forest a two-hour drive from the city. It is my first introduction to the direct action that, by summer, becomes one of the largest acts of civil disobedience in Canadian history.

As Pacheedaht elder Bill Jones speaks to the crowd, the manager of the hotel I am sitting in front of offers me coffee. I explain that I don't drink coffee. "Well, if you need the washroom, feel free to come inside," he says, showing his allegiance to the cause. With temperatures rising each summer, the local population is painfully aware of our need for these ancient trees that cool the air.

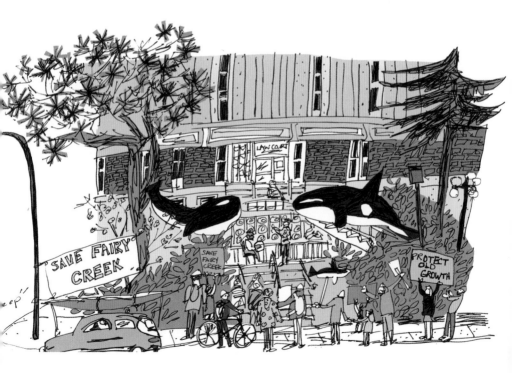

"Oh, it isn't really an art deco house!" says the owner of 1342 Thurlow Road. "We just really liked that style and redid it." This white house with red railing, one I see every Saturday while attending the Moss Street Farmers Market, could have fooled me. Luckily, if you are keen to find true art deco buildings in Victoria, the book *The Artistry of Art Deco* by Mary Conley can lead you on a self-guided tour of buildings from that time.

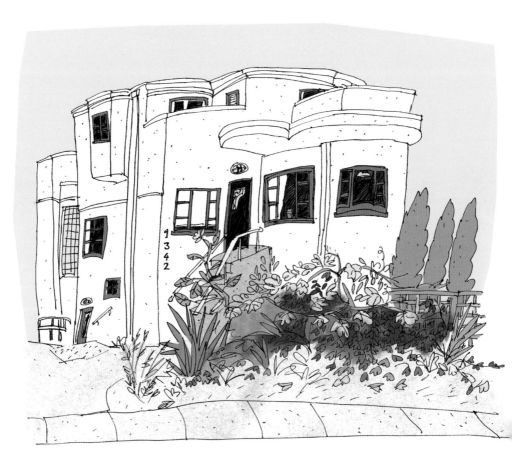

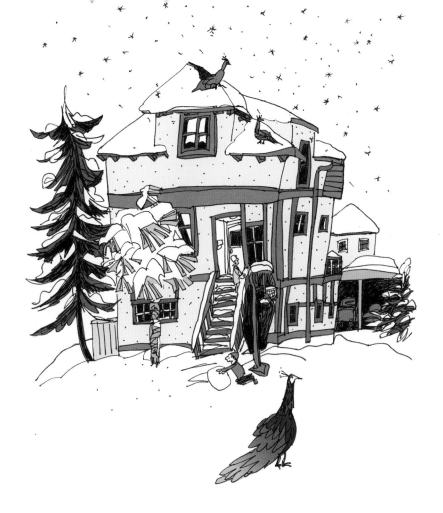

A freak snowstorm in February makes for a memorable Valentine's weekend. Even more so when, after braving the walk to the Moss Street Farmers Market and being rewarded with extra goodies given out by appreciative farmers, butchers, and bakers, I look up and see a peacock in the snow, and two more on the roof of a house! Peacocks are common in Victoria—their wailing accompanies most of my walks in Beacon Hill Park—but this was my first time seeing them in such a residential setting—and atop a building!

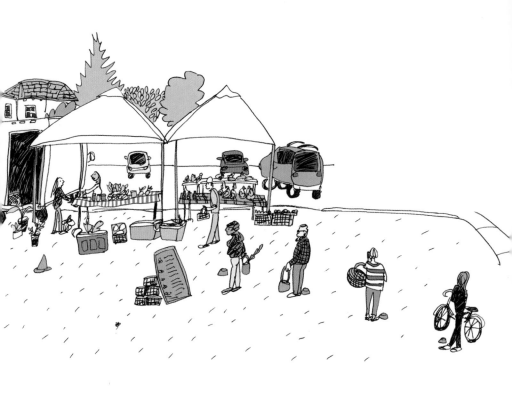

The Moss Street Farmers Market spreads into two adjoining fields to allow for distancing, with long lineups that make for a good place to call my parents on the weekends as I wait for organic food from local farmers and producers. Overheard in May 2020:

"Oh, you hugged me! That was the first time someone touched me in two and a half months. I am in my own bubble. I haven't decided if I am going to add anyone to my bubble." I can relate.

Friends Eddy Charlie and Kristin Spray are set up each Saturday at the Moss Street Farmers Market to promote awareness for Orange Shirt Day. Held each year on September 30, it grew from Northern Secwepemc author Phyllis Webstad telling her story in 2013: she had her orange shirt taken from her at the age of six when she was brought to St. Joseph

Mission residential school. Thanks to her sharing, people across Canada are in the process of learning that a lot more than just clothing was taken from young Indigenous children when they were removed from their families. Eddy and Kristin were inspired by Phyllis, and began selling T-shirts with local artist Bear Horne's design in 2015 to mark Victoria's event for Orange Shirt Day. The message is that Every Child Matters.

Eddy, who has lived experience as a residential school survivor also shares his stories with market goers:

"I want to release what is inside me. All that fear. All that anger. All that pain. And I want all of Canada to know why we are the way we are today."

A man named Ted tells me he has tended this garden at the foot of Rockland Avenue for thirty-nine years. The many blooms, his retriever Buster's smiling, tail-wagging welcome, and the buzz of bees and chirping of birds make it a place of note on my walk home, so one summer evening I stop and sketch it. After winter has passed and the growing season begins again, Ted is out weeding. "I dug up the grass in the median years ago and planted veggies and herbs because the dandelion seeds would blow into the garden. Now I just have to do three to four days of heavy weeding in the spring, like I am now, and then it kind of takes care of itself."

Bikes get tuned up at Fairfield Bicycle Shop, while market goers heading
home from the Moss Street Farmers Market pass by and a brother and
sister devise their own sidewalk games.

Graffiti on garbage containers and fluttering cherry blossoms hold my interest as I sketch on Meares Street. The Victoria Shorin Ryu Karate School is a branch of the Okinawa Shorin-Ryu Karate Shinkokai, an international organization founded in Japan in 1985. It holds the motto "Compassion, humility, gratitude, patience, perseverance." These qualities seem to be exemplified in the expression of the person painted at the back of Mantra, an Indian restaurant next door.

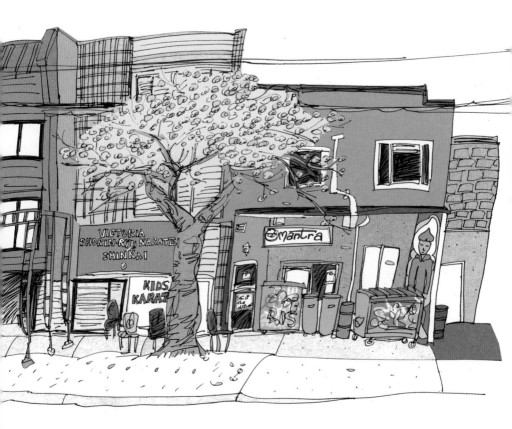

Across from the Christ Church Cathedral, dancing
trees add their own filigreed tracery to that
of the sombre, gothic-style building. The old
tombstones in this green space referred to as
Pioneer Square are witness to regulars who often
spill the sounds of reggae throughout the park,
congregating around shopping carts that contain
their possessions and an ad hoc speaker system.
I sit on a park bench, bobbing my head to the
music, a little pause on my way home.

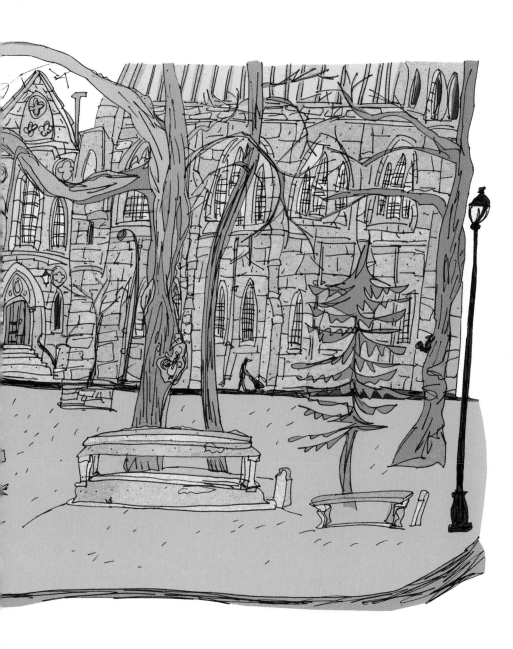

There are not just one, but two Bubby Rose bakeries on Cook Street. I choose to sketch the location closest to my place, flanked by My Thai Cafe and Urge Studios tattoo shop, all popular neighbourhood haunts. In addition to this one and the nearby location in the heart of Cook Street Village, there are three more Bubby Rose locations throughout Victoria, making it part of the fabric of the city.

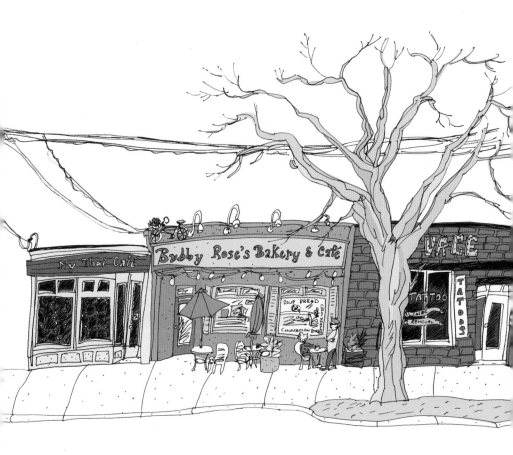

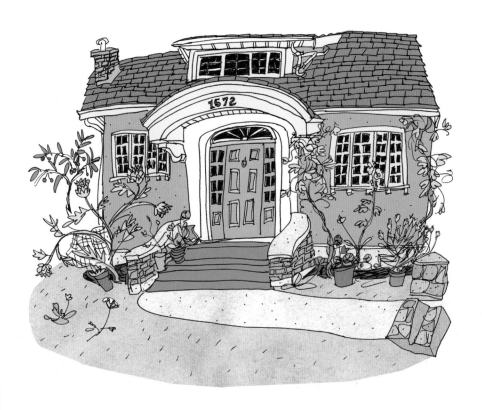

I stop to sketch this cheery garden, where artichokes, hollyhocks, and cherries grow together, on my return home to Rockland after biking along Richardson Street to Willows Beach in Oak Bay. Despite the hot weather at summer's height, and my exertion while biking, the water is still too cold to swim in. Instead, I wait for the evening air to cool me off, as the temperature often drops markedly after 7 p.m.

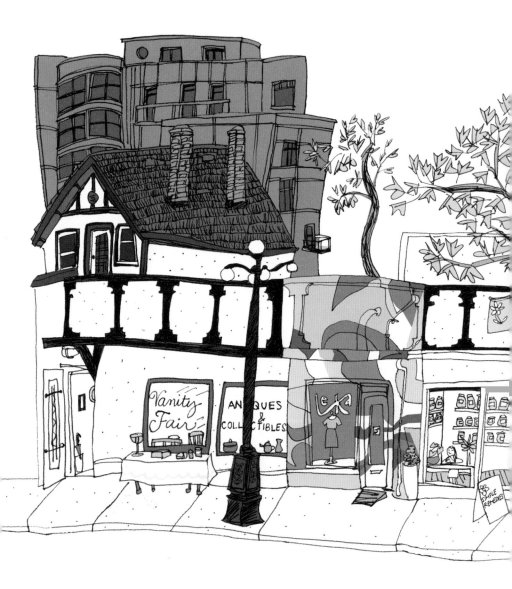

Vanity Fair

ANTIQUES & COLLECTIBLES

leka

SIMPLE REMEDIES

If you subscribe to the idea that we should be reducing, reusing, and recycling, this stretch of Fort Street in Harris Green is a great place to do so: purchasing gently used household goods at Vanity Fair Antiques & Collectibles, locally made and sustainably sourced clothing from Leka, high-quality herbal medicine with minimal packaging from Simple Remedies, and second-hand books at Sorensen Books all seem like good ideas.

On this day, Sorensen Books' owner Cathy has a trolley set up at the door for socially distanced purchases and a moving sign on the window: she is relocating to the street-level retail space of the terracotta-coloured condo building that I can see rising up from View Street, just behind her current spot. With its curved facade, the building is aptly named the Jukebox, proving that what is old is new again.

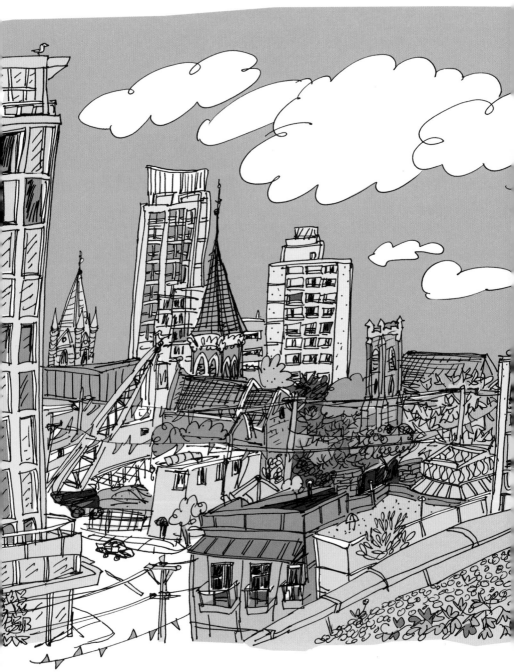

Friends let me use their condo in Harris
Green while they are away, giving me
a window into a different kind of
lifestyle, including access to a rooftop,
where I sketch spires and skyscrapers,
looking back toward downtown. Below,
I see orange triangles fluttering in the
breeze, strung up like bunting for a
street party, but instead signalling more
construction ahead.

Island Blue Print Co. was founded in 1912, initially making maps on linen, including a replacement for the original map of Greater Victoria, which was burned in a fire at Victoria's legendary booksellers and stationers, T. N. Hibben & Co. Today, this flagship location serves three needs through the art store for framing and art supplies, the digital print centre where I print my cards and calendars during my time here, and Printorium Bookworks specializing in printing and binding books.

The Printorium and digital print centre are housed under a sign that faintly reads "Pantorium," a ghostly reminder that the curiously—and similarly—named Pantorium Dye Works occupied the building until 1950. Online, I find an ad from the 1920s that advertises its services as follows:

> Shoe repairing
> Cleaning and Pressing ladies'
> and gentlemen's clothing
> Cleaning rugs, drapes, curtains,
> Chesterfield slipcovers, etc.
> Cleaning and re-blocking hats

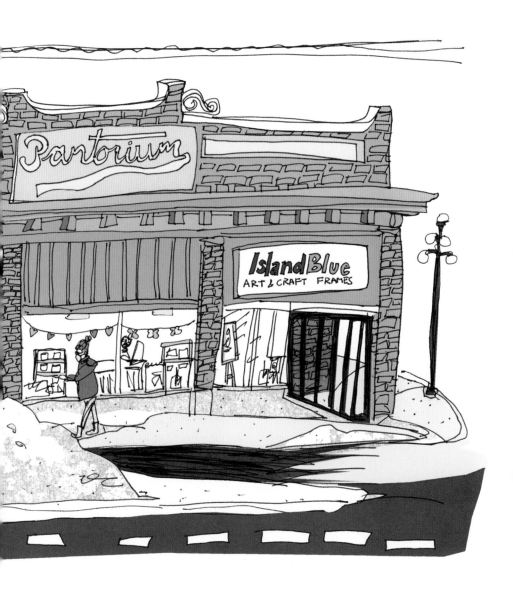

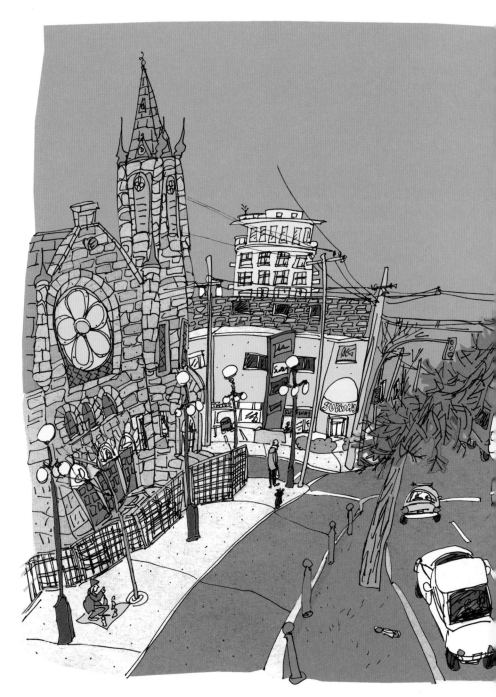

A leaning tree growing out of Pandora Avenue catches my eye and I sketch it, along with the barricaded Victoria Conservatory of Music and the bright yellow awning of a Subway. Patrons of the nearby Our Place Society stop to say hello and talk to me about their own love of sketching. Our Place was purpose-built in 2007 to serve vulnerable populations in the Greater Victoria area, bringing together two organizations that previously worked independently: the Open Door and the Upper Room.

FERNWOOD, NORTH PARK & OAKLANDS

Built in 1887 in Fernwood, the Belfry Theatre's home, a former church, keeps watch over the neighbourhood square, its spire the highest landmark in sight.

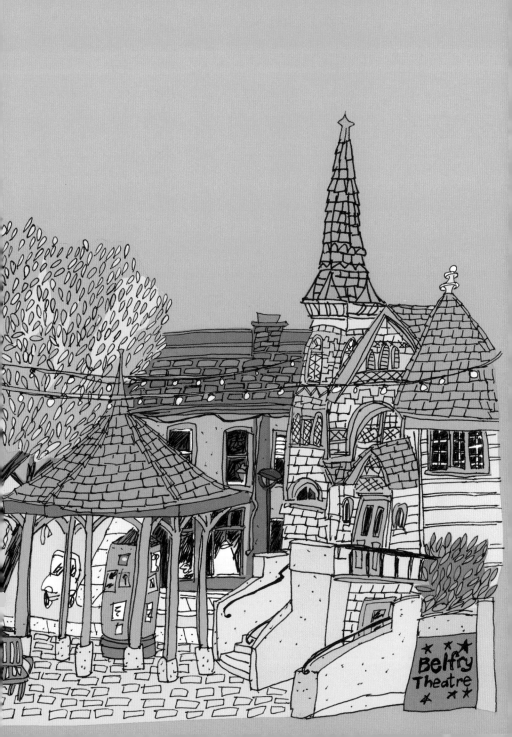

Belfry
Theatre

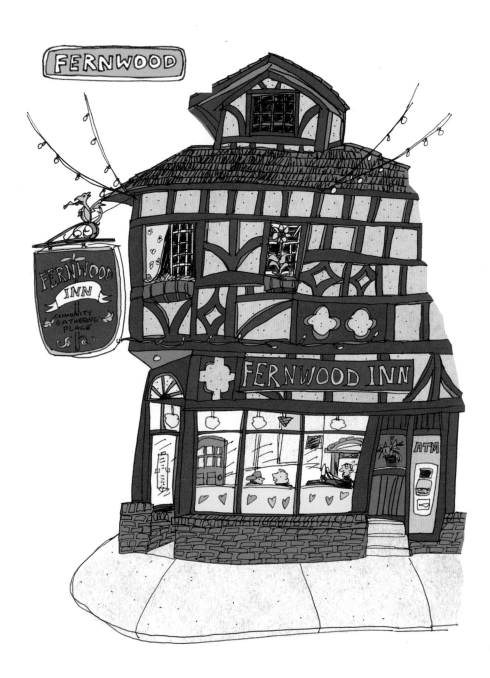

Among mostly glowing Trip Advisor reviews is one from RT, a "level 6 contributor" who, according to the website's stats, has visited 205 cities around the world.

He calls the Fernwood Inn and Pub "a true neighbour," and goes on to say:

> This place is for regulars, or visitors who would like to feel like regulars. The building draws you closer; rain or shine the corner location feels cozy. The staff are like cousins you haven't seen in a while. This place anchors the village, along with the Belfry Theatre and Little June Cafe. This time I was here after the lunch crowd had left and happy hour revellers had yet to come. A quick dessert after [the] theatre matinee. I was treated like I had ordered the most expensive item on the menu. That's class.

Though I only ever dined a few times on the patio, I also enjoyed my visits to this neighbourhood institution.

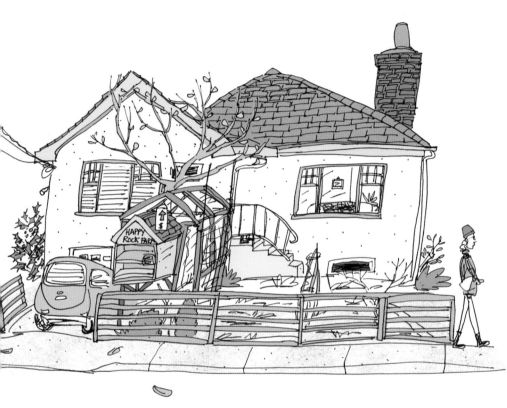

Just down from the Fernwood Inn is the Happy Rock Farm. The farm sells produce on a self-serve honour system, but the shelves are bare the day I sit down across the street to sketch it, the front garden getting ready for its winter sleep.

While sketching a large yellow house at the corner of Camosun and Balmoral, I hear a raven caw and the click of a local punk's Doc Martens on the sidewalk. A few moments later someone zooms home from Vic High on their skateboard. I later find out more about a previous, notable owner of the slightly ramshackle but obviously well-loved home via the Fernwood Community Association website. Paul Phillips was known as a driving force behind the development of Fernwood's Neighbourhood Improvement Program. He was instrumental in protecting heritage buildings that would have been demolished otherwise, forming the Spring Ridge Housing Co-op in the process. He also helped build the first curbside recycling box, a precursor for the ubiquitous blue boxes left out on curbs today. As the owner of three Fernwood properties, he created affordable housing for over a dozen people. As Phillips once acknowledged, the process may be messy, but the results are well worth it.

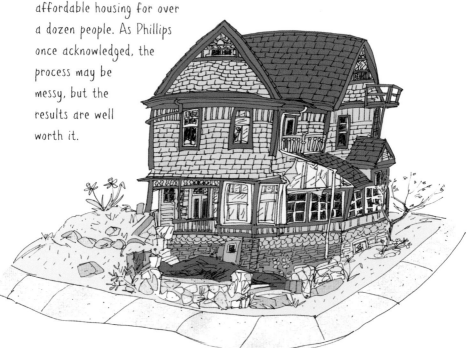

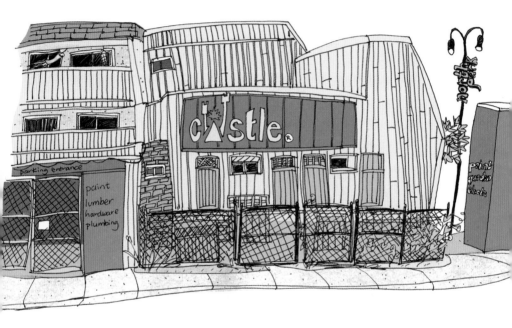

Cook Street Castle Building Centre on North Park Street is where I go to buy rags by the bag when I tune up my bike and clean its chain in the spring. It is also where I find myself come winter time to buy traps when mice turn up in my apartment. So it is with fondness that I sketch it, grateful for a hardware store within walking distance of my place—and so close to Cold Comfort Ice Cream!

Despite a multitude of other options on the menu, the Plain Jane vegan ice cream sandwich appears to emerge as the clear frontrunner for crowd favourite at Cold Comfort Ice Cream, based on how many times I hear it ordered while sketching the shop's side window. The shop owner, Autumn Maxwell, has a unique operating motto: "Doing whatever the hell we feel like since 2010." I have no qualms with either the motto or the Plain Jane as favourite, which is truly impressively creamy for a vegan ice cream sandwich.

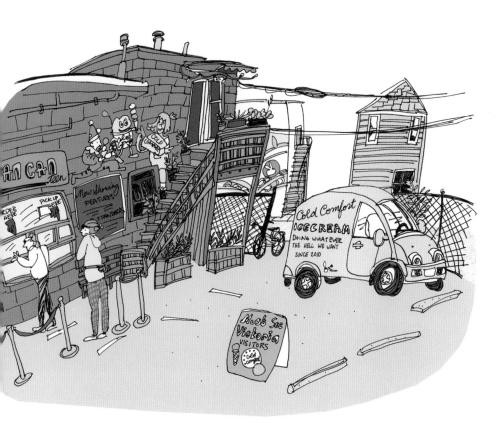

OAKLANDS

The Local General Store is a one-stop shop for the Oaklands neighbourhood, selling local cards, beauty products, dry goods, and fresh organic fruits and veg. As I sketch, a shop regular fills her basket from wheelchair height.

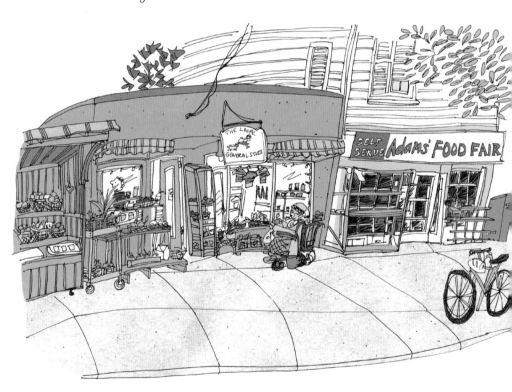

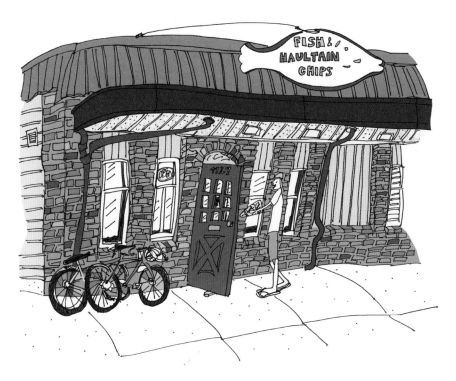

One online review I find for Haultain Fish & Chips says:

> We used to live 3 blocks away in the 70s. We now live in
> Los Angeles. I also lived in England. I've eaten F&C from
> London to Inverness, Scotland, Victoria to Hong Kong.
> There is no better place on the planet. It's a wasted trip
> to Victoria if Haultain is closed. We never fail to eat
> there. We send our friends there. No one has ever failed
> to say "The BEST Fish and Chips EVER!!"

I agree. I did get the fish and chips one evening. Wrapped in newspaper
and eaten on the side of the road, it was delicious.

At 1,900 square metres and located in the Hillside Centre, Victoria's version of a shopping mall (too elegant and small in scale to truly feel like a mall), Bolen Books is not your typical independent bookstore. Now in its fortieth year, it still has all its heart, including hand-painted windows bringing the best titles of the year to you in a larger-than-life format.

RAYNOR WINN

THE WILD SILENCE

A PROMISED

Bolε

BARA OBAM

ROCKLAND, GONZALES & JUBILEE

Rockland is where the Lieutenant Governor lives in a large stone house. The gardens are open to the public and tended by volunteers. In June the gate to the Rose Garden beckons with a sweet scent carried in the warm air.

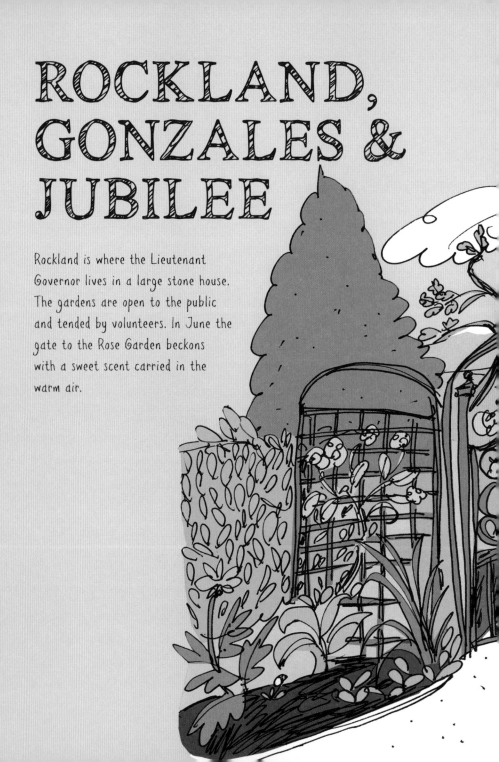

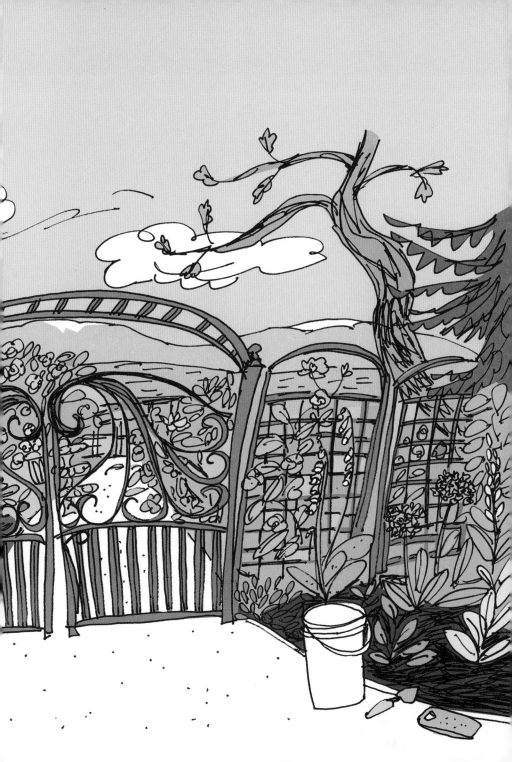

Bright-pink foxgloves stand tall along a garden path with Government House, the Lieutenant Governor's official residence in behind. The bleached yellow leaves of Garry oak trees belie the fact that it is still summer, just very dry.

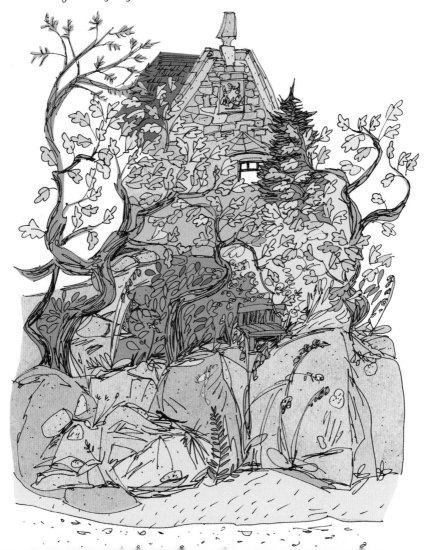

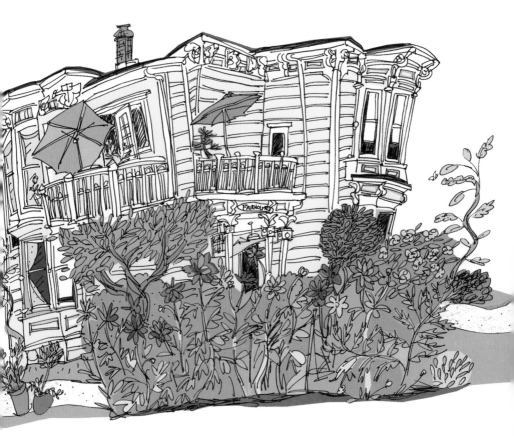

Glad-looking dahlias make for a warm welcome at Fairholme Manor, a B&B where some of my out-of-town visitors stay during my time in Victoria. It means that I am able to join them for the most delicious breakfasts, a favourite being poached eggs with smoked tuna, procured from local fish merchant Finest at Sea.

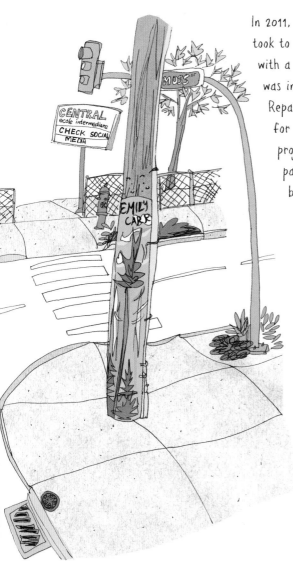

In 2011, local artist Beth Threlfall took to Victoria's telephone poles with a paint can in hand. She was inspired by Oregon's City Repair Project, which advocated for community-based painting projects in public spaces. Beth's painted poles caught on, soon becoming an annual event.

This particular pole I sketch on Moss Street is seemingly a transplant from the bordering neighbourhood of Fernwood, Victoria's epicentre of painted telephone poles. It is painted in artist Emily Carr's distinctive style, bringing her love of the forests of the Pacific Northwest to the sidewalks of the city where she spent her formative years and was eventually buried.

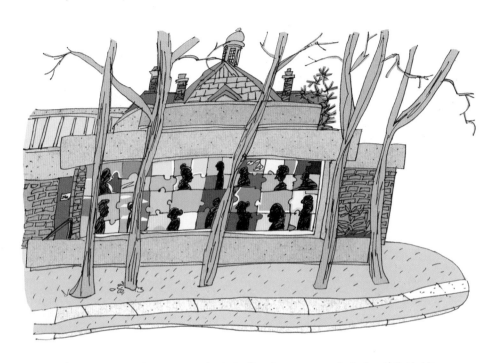

With mentoring from artist Andréa Searle, a group of Cedar Hill Middle School students who identify as girls of colour, called Melanin Magic, have painted a mural on the exterior of the Art Gallery of Greater Victoria. The participants based their art on the question "How do we fit together?" From there, the mural developed into a jigsaw puzzle of all the participants.

Written within one puzzle piece is a quote from Martin Luther King Jr., with the young artist's own emphasis, based on her use of capitals:

"I have a DREAM that my four little children will one day live in a nation where they will NOT BE JUDGED by the COLOUR of their SKIN but by the CONTENT of their CHARACTER."

According to the Victoria Heritage Foundation, dentist Dr. Thomas Joseph Jones had this house built in 1908 at the corner of Linden and Rockland, to house him and his wife Annie (née Webster), and they lived there for the rest of their days. They named the house Dundalk, but I know it as home.

It's where I'm renting an apartment for fourteen months. My tiny one-room space is aptly named "the Jewel Box" by my landlords Mikal and Lisa, who lovingly restored this Queen Anne-style mansion into a multi-unit apartment building. They had purchased it from their neighbour, Larry, who bought the house in the 1970s, when it was run as a boarding house. There was just one kitchen housed behind the grand staircase, serving all the occupants.

As in so many parts of the world, the occupants of this house on Rockland Avenue in Victoria put their hearts in their windows (or at least paper ones!) during the initial weeks of the pandemic lockdown. It was one of the little things that helped in such a time of uncertainty.

GONZALES

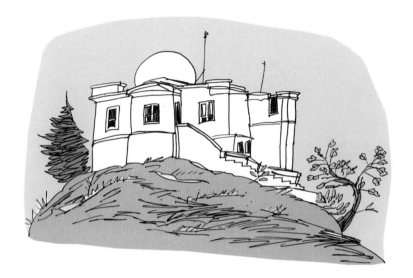

The Gonzales Hill Observatory, situated in Walbran Park, was a weather station for seventy-five years. When you see it perching against blue sky, you could be forgiven for mistaking its whitewashed walls for a building in Greece, its dome rising like an errant moon above the otherwise squat building.

JUBILEE

Still sweaty from dance class with contemporary dance artist Kathy Lang at Seda Dance on Begbie Street, I sit at a nearby bus stop to sketch this strip of colourful shops on Fort Street, presided over by Garry oak trees and an old Victorian house, waving the bus on when it comes by.

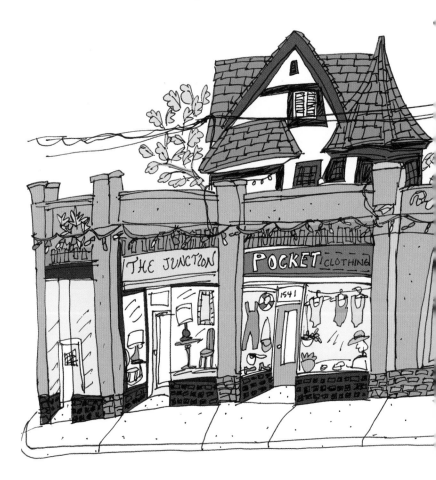

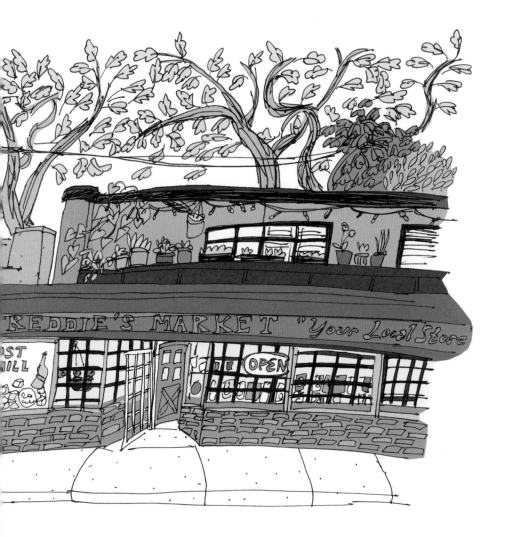

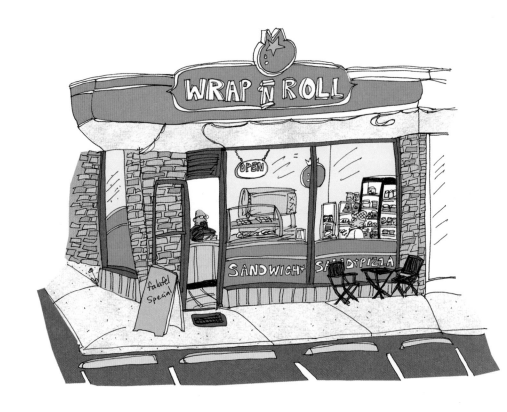

Wrap 'N' Roll's window sign advertises sandwiches, salads, and pizza, but this barely scratches the surface of all that is on offer. Tubs of hummus and baba ghanoush, bottles of rose and orange blossom water, za'atar, and olives all vie for my attention while I wait for a shawarma with pita made in house and laced with pink pickled turnips. A few weeks previous there were lineups down the street when this community favourite responded to the explosion in Lebanon. All profits from that day were donated to the rebuilding efforts.

Tucked beneath a large green house with a penny slot top window is the Still Room Perfumery, offering exclusively natural scents. You can go on a two-hour scent journey with its owners, Karen Van Dyck and Stacey Moore, to find your own signature perfume. Its neighbour, French Vanilla, rounds out the street's offerings with items for your garden and home.

If I were to make a perfume for Victoria, it would capture the smell of plants found in my pockets after meandering walks, plucked from the edges of overabundant gardens that would never miss a few lavender buds, rosemary sprigs, or sticky sweet calendula flower heads. Folded in would be the briny smell of sea, and the slightly more ineffable scents of sun on rock, shade in a forest, and tomato plants grown in container gardens on back decks.

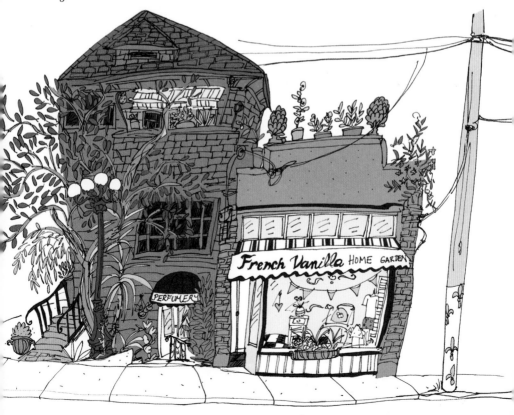

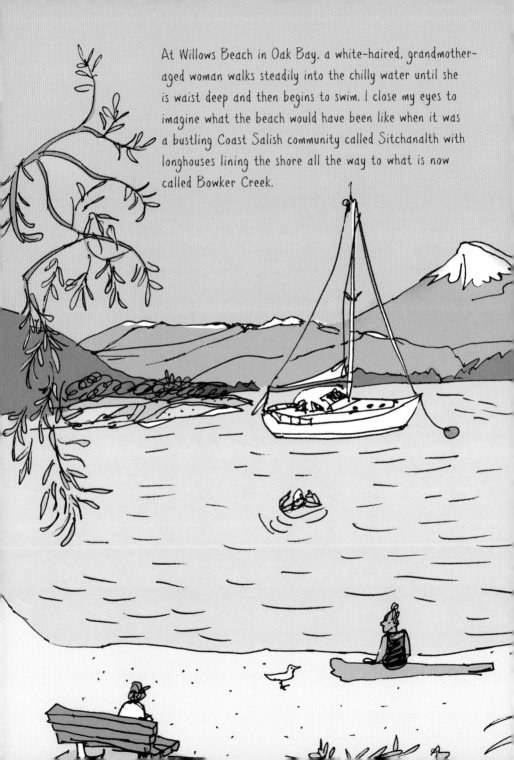

At Willows Beach in Oak Bay, a white-haired, grandmother-aged woman walks steadily into the chilly water until she is waist deep and then begins to swim. I close my eyes to imagine what the beach would have been like when it was a bustling Coast Salish community called Sitchanalth with longhouses lining the shore all the way to what is now called Bowker Creek.

OAK BAY, UPLANDS, CADBORO BAY & UVIC

OAK BAY

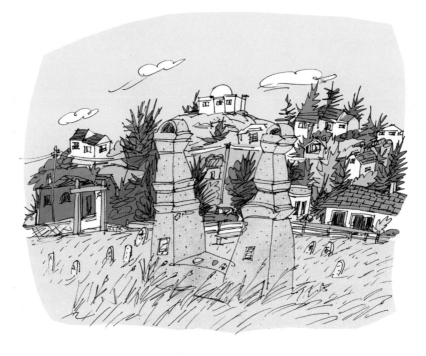

The Chinese Cemetery at Harling Point was first used in 1903 to bury Chinese residents of Victoria. The land was purchased by the Chinese Benevolent Society, as it was felt the site offered good feng shui with the combination of ocean front and rocky outcrop behind. The remains were dug up every seven years, and the bones were cleaned and shipped back to China for their final resting place, until 1937, when war in China prevented the practice. The bones of some 900 people awaiting the journey in a no longer standing "bone house" were buried in a mass grave in addition to the 400 individual graves. On a spring day I see that someone has left a mandarin orange as an offering to the dead.

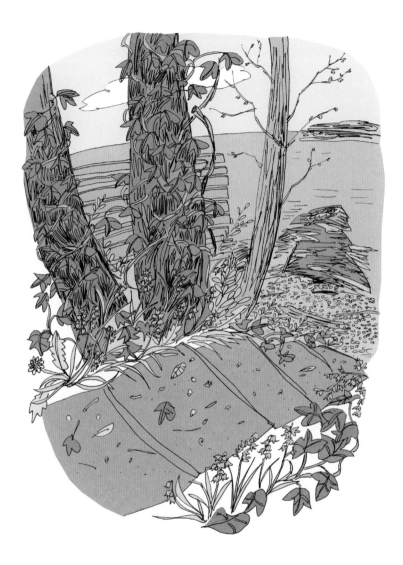

Bluebells nod in the breeze, matching the blue of the ocean beyond, lining a beach access in springtime.

While I sit with the Oak Bay Marina at my back, my mind is kept occupied by a series of fairy-tale-looking houses and busy otters among a kelp bed. I am waiting on this late July evening for updates via my family's WhatsApp chat on the status of my soon-to-be-born niece. By the time I bike home, I've learned that Hannah has arrived, and both she and my sister, Laura, are healthy and well. The next day I return to nearby Willows Beach and gather some smooth stones to bring to her nursery in Vancouver.

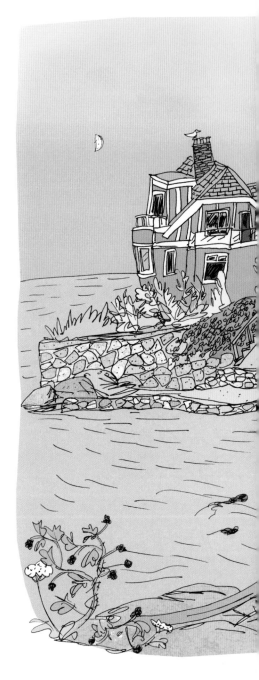

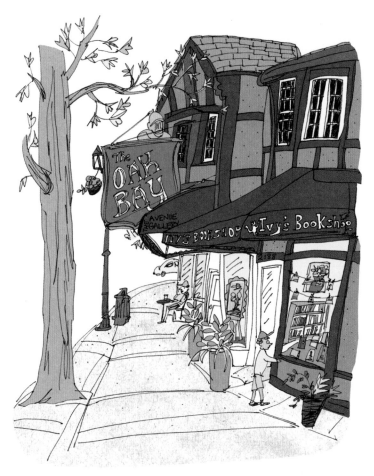

From 1936 until 1987, the Oak Bay Theatre showed everything from Hollywood blockbusters to films that were part of Oak Bay High School's curriculum, until the building was gutted and became commercial space. These days, it houses an art gallery and coffee shop. Its neon sign remains as a reminder of its film days, as well as a welcome sign for the neighbourhood, which includes Ivy's Bookshop, home to a great selection of books for all ages, and Period Fine Bindings across the street, where ancient religious and Shakespearian texts are rebound in a fashion that brings you back in time about 500 years.

As I sketch the Oak Bay Fire Hall festooned with seasonal decorations, a man carrying a Pic-a-Flic cloth bag stops and asks:

"Are you drawing the whole thing? If you do, can you add an apostrophe to 'Season's Greetings'?" as he gestures toward the large capital letters that spell out SEASONS GREETINGS, no apostrophe in sight. "It bothers me every time I see it."

Incidentally, Pic-a-Flic is a still-functioning local video store with over 25,000 titles in its collection, bucking the trend toward online streaming.

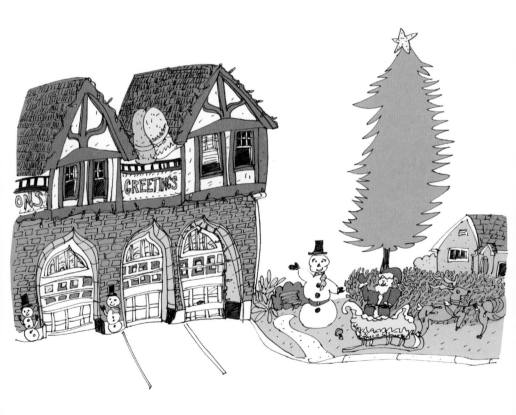

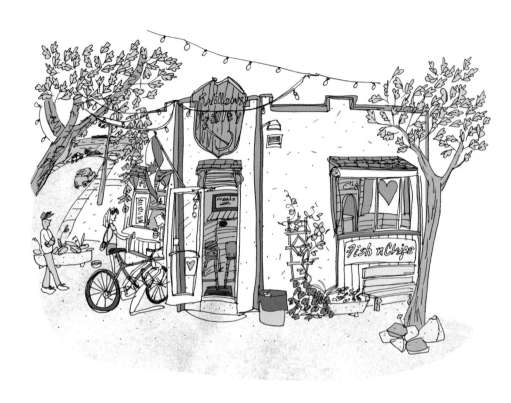

Love is in the air at two unique Estevan Village eateries, both located on Estevan Avenue, a stretch of shops that forms the heart of this village in Oak Bay.

The current owners of Willows Galley Fish & Chips, Dave and Jennifer Higgins, had their first date at this very restaurant, which opened in 1980, long before they knew that they would one day run the joint.

Further up Estevan Avenue at Nohra Thai is another couple bringing their passion for good food to the community. Joel and Phen Bryan met when Joel was a tourist scuba diving in Phen's home country of

Thailand. Phen, having been an activist, tour operator, and translator, was well versed in cooking alongside these other careers, as I learn from the restaurant's website. I was particularly struck that her mother had her prepare a meal for a visiting dignitary at age seven, including the selection and slaughter of a chicken for the meal.

It was when the couple moved to Victoria that this skill in preparing Thai food became their business and Nohra Thai was born.

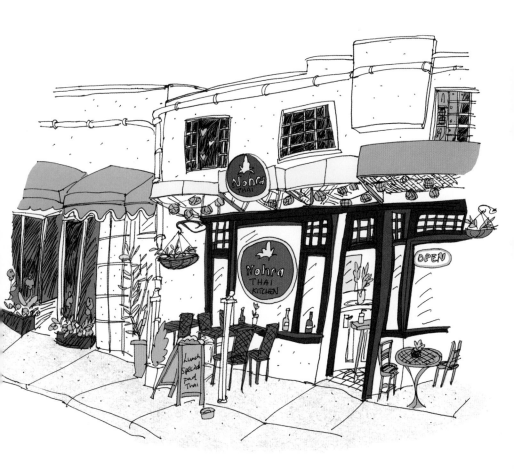

Uplands Park is a prime example of a Garry oak ecosystem, a unique landscape made up of meadows, rocks, and Garry oak trees, occurring only on southeastern Vancouver Island, some Gulf islands, and two sites east of Vancouver. This particular site has over 20 rare and endangered plants. I join Friends of Uplands Park on a sunny October day, removing invasive plants and planting native species, including mock orange.

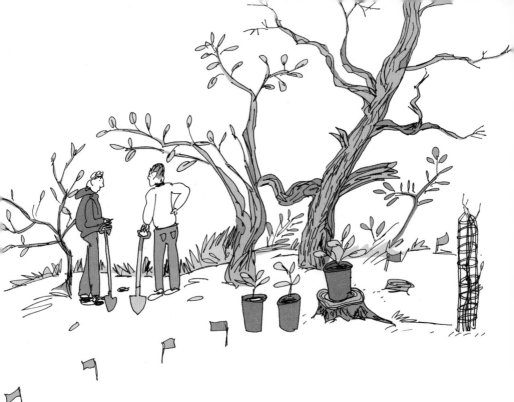

"The deer love mock orange," says Margaret Lidkea, who has been recognized by the BC Achievement Foundation for her commitment to stewarding the land and involving young people in the process. "I have a recipe for a deterrent though." I scribble it alongside a sketch attempting her likeness as she hands out shovels and gloves to a regular crew of volunteers.

> 1 egg
> Quarter cup of milk
> Drop of vegetable oil
> Some eucalyptus oil, to make it smell nice
> Put all ingredients in a spray bottle, shake well, and
> spritz on plants to keep deer from eating them.

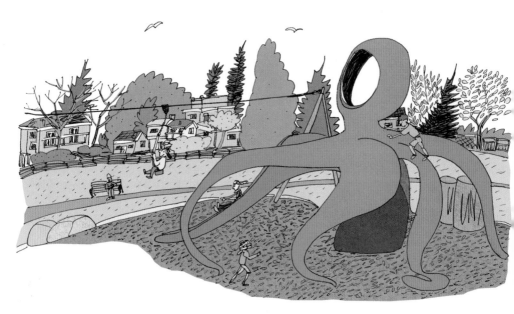

As I sketch the large octopus that is a centrepiece of Gyro Park, a young girl walks by with a large jar of pickles, eating them with gusto and offering them to her playmates. A dad walks by, daughter in his arms, singing "Skinnamarinky dinky dink / Skinnamarinky doo / I LOVE you . . ." a classic children's anthem made popular by Canadian children's music performers Sharon, Lois & Bram.

This house on Broadmead Avenue with two jack-o'-lanterns in front
is very close to UVic (the University of Victoria). I know it is unlikely
that the university students trick-or-treat in the neighbourhood, but
it makes me think about how I only really embraced Halloween in my
twenties, no longer as nervous about finding the "right costume" as I was
in elementary and high school.

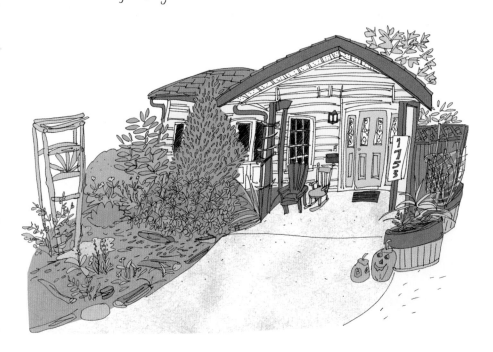

The Finnerty Gardens on the
University of Victoria campus
are a tranquil place for students
and visitors to go. The gardens
opened in 1974 when several
hundred rhododendrons were left to
the university from the estate of
Jeanne Buchanan Simpson, who had
collected many species of the plant
with her husband, George, on their
Lake Cowichan property since the
1920s. On a particularly wet fall day,
the rhododendrons are not in bloom,
and instead I sketch a bamboo grove.

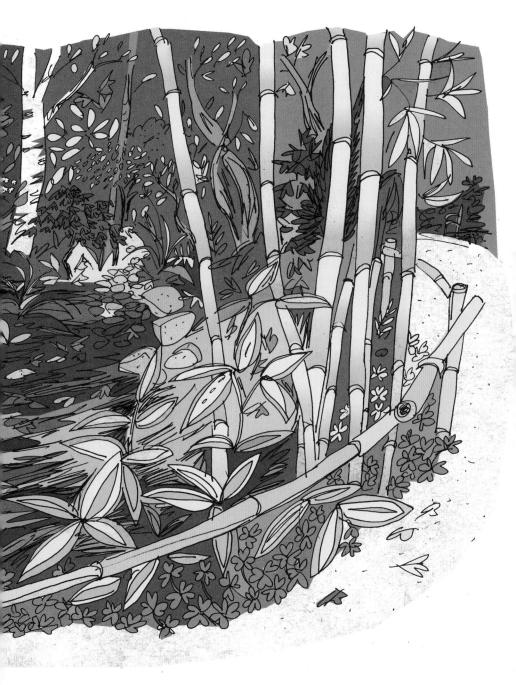

HILLSIDE, QUADRA VILLAGE & ROCK BAY

At the top of Hillside is yet another place to enjoy sitting among Garry oak trees at Summit Park. From my vantage point I have a beautiful view of a Sikh temple, the city beyond, and the sky, which is a lovely golden hue.

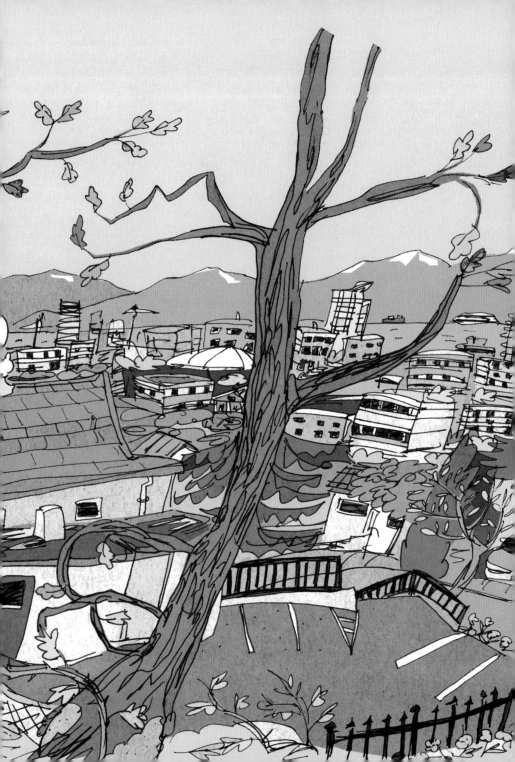

HILLSIDE

In a home garden on Blackwood Street a combination of winter squash, maize (corn), and climbing beans, which is referred to as the Three Sisters for the way the three vegetables support each other's growth, makes me curious whether the people who live here—who may or may not be Indigenous—have a knowledge and appreciation for Indigenous culture. Originating in Mesoamerica, this method of growing moved north over generations to the Haudenosaunee people. Referred to by the French as the Iroquois, they used these plants for food and trade.

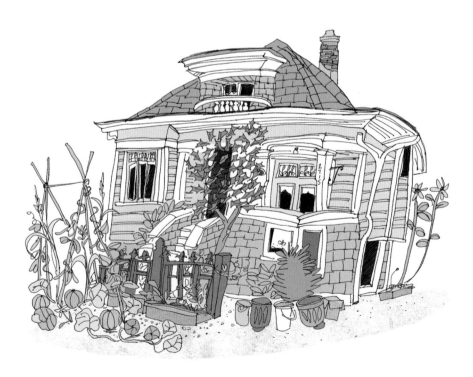

The anarchist bookstore and zine library on Quadra Street, Camas Books & Infoshop, is a treasure trove of good books. When I visit, I browse the herbal communal medicine cabinet nailed to the shop's wall. It contains various wild-harvested herbs with labels in handwritten scrawls indicating the date the plant was gathered and its name: pine pollen, chickweed, rosehips, raspberry leaf, and feverfew, to name a few! A money jar indicates it runs on a trust-based, pay-what-you-can system.

The Roxy began its life as a movie theatre named the Fox in 1949, surviving various ownership and name changes since. It eventually transitioned into a live theatre venue and home for Blue Bridge Rep, a professional theatre company.

By the time I sketch the distinctive blue building, live performances are on hold, and it has become a billboard for a local festival: the Out There Art Festival animates the streets and public spaces of Quadra Village with locally produced art over the course of a September weekend. It was born out of a time of social distancing, the antithesis of smooching in a darkened theatre like the Roxy, where the owner in the 1980s removed the chairs' arms to make it easier to do so.

OUT THERE

blue bridge AT THE
ROXY

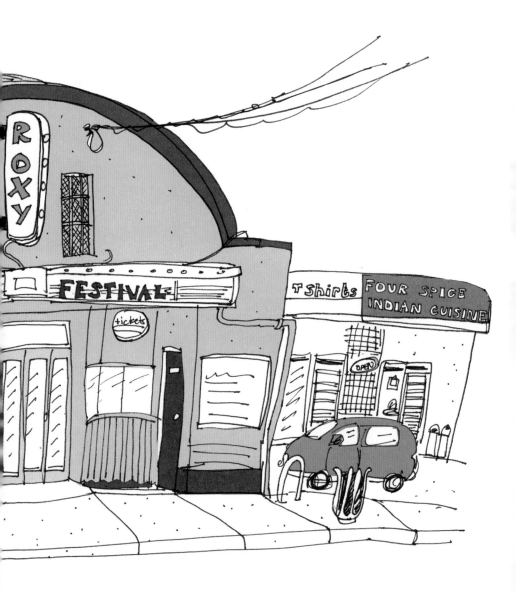

Since 1998, Caribbean Village Cafe owner, James Bowen, has been serving up homestyle Caribbean food as well as generously sharing philosophical conversation with a side of horticulture; his vertical container garden bursts with colour.

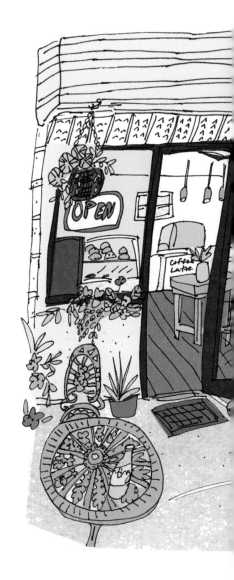

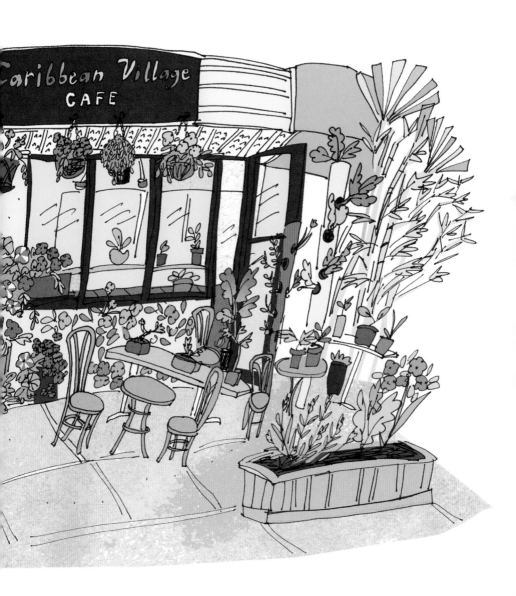

At one time a family home for the prominent O'Reilly family, Point Ellice House has been around since the 1860s and became a national and provincial historic site open to visitors until recently. It's located in Rock Bay, now a mainly industrial neighbourhood, which makes for slightly incongruous neighbours. On this day I hear crows and seagulls circling at the nearby dump, but I can smell the sweet roses in bloom in the Point Ellice House gardens, and beyond the house I see the Gorge and the glint of sunlight on water through the many trees planted by the O'Reilly family.

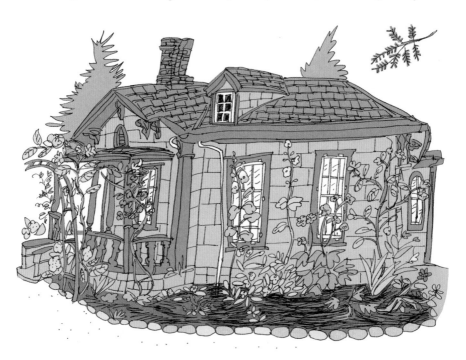

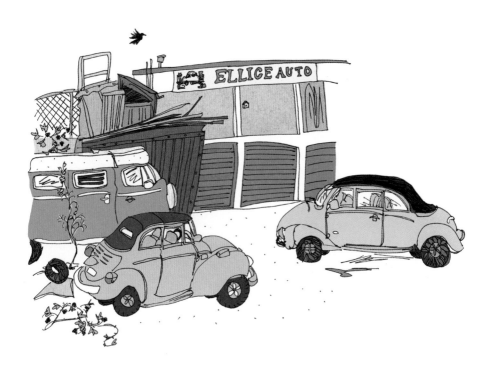

Neil and Liane Gustafson have run Ellice Auto since 1975, servicing cars from as far back as the 1950s. There is a regular rotation of Volkswagen vans and beetles with colours that match the ice cream flavours at the nearby Parachute Ice Cream, which, along with Rock Bay Square artist studios, Hoyne Brewing Company, and a smattering of coffee shops, means there are plenty of treats to be had and art to be seen while you wait for your car to be fixed.

I've heard stories of a music venue in the basement of a nearby house. Called the Rat's Nest, it was a centre of the local punk scene up until 2013. There are still rats around; I see them scuttling on late night walks home from my studio, a block over.

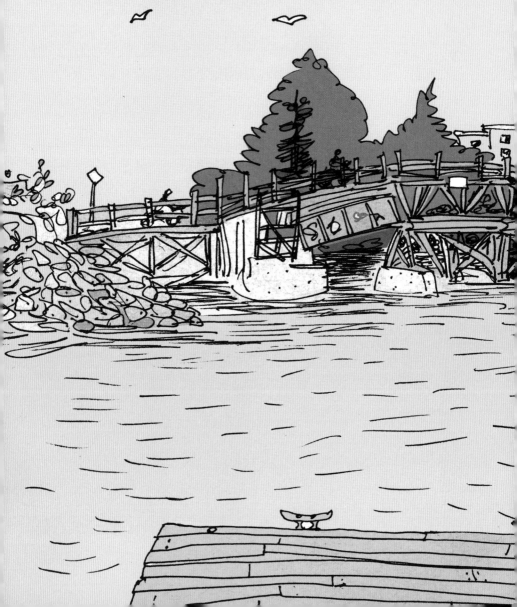

VIC WEST & ESQUIMALT

The Selkirk Trestle is my route home from my studio
in Rock Bay, taking me over the Gorge in the evening,
and momentarily into Vic West. I enjoy the orangey
pink and sometimes purple evening sky while biking
along the Galloping Goose Trail, traversing the water's
edge until I scoot onto the Johnson Street Bridge as
darkness falls over the city.

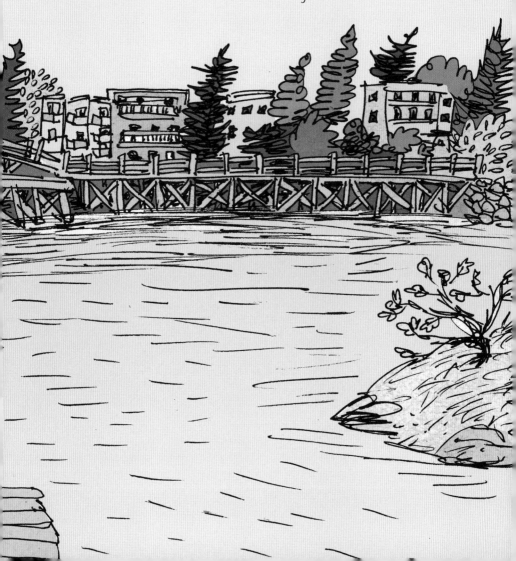

VIC WEST

This beautiful old house on Catherine Street is where two friends used to live in one of the several apartments housed inside. They hired me to sketch it as a memento, with strict instructions to include the wonderful monkey puzzle tree in its garden. While I sketch, I hear the door of a Little Free Library behind me open and close. Little Free Libraries are littered throughout the city, making for a constant circulation of books.

St. Saviour's Anglican Church sits at the corner of Henry Street and Catherine Street and is currently home to the Maple Leaf School of Russian Ballet.

Someone passing by says, "Ah, the Rainbow Kitchen used to be around back."

I learn that the Rainbow Kitchen started at the church in 2001 as a weekly drop-in organized by parishioners providing coffee, tea, and sandwiches. As the passerby noted, it has since expanded, no longer located in the church. Instead, it has grown to be a hub for food security in the entire Capital Regional District. I see some evidence of a rainbow, however, in the form of a curved bench on the church grounds, made from mud and straw and tiled with bits of colourful glass and broken ceramic. With a roof over top, it still makes it feel like a welcoming spot.

Catherine St

I complete a house portrait for a friend whose house has since been renovated beyond recognition, apart from the Boler trailer that still sits in her driveway and the fantastic garden that still gets her boys outside playing and away from their respective screens. She hangs this portrait, which I completed using photos as reference, in her front entry as a reminder of a previous chapter in her home's life.

It is a busy day at the skate park in Vic West Park, where I spy many skateboarders, some bikers, and one intrepid rollerblader.

The sky is clear in Vic West where people line up for pastries at Fol Epi. I overhear someone say their flight was delayed due to fog.

"Fog?" says their friend incredulously.

"Yeah, I was supposed to take the 2 p.m. float plane to Vancouver, but fog on the mainland is holding things up."

With that, they head off with their treats for a little walk along the Gorge, not the worst layover.

"Taco night" puns abound, made by folks out on their evening walks passing by a motor yacht named Taconite (which in fact is a type of iron ore). The vessel is sitting alongside the Galloping Goose Trail in the dry dock of Victoria's Inner Harbour undergoing repairs when I sketch it. With its teak decks and hull, its luxury status is evident even to a casual passerby. Built in 1930 for the Boeing family of aircraft fame, it has hosted guests as diverse as Amelia Earhart and Al Pacino.

The Galloping Goose Trail serves as
a seam between the busy activity
of Vic West and the Gorge itself;
an urban garden/market, offices
and homes, cyclists and walkers,
rowers and a floating hot tub all
co-exist in a fairly narrow slice
of space.

I come home from a session
of hot tubbing down the Gorge
with Hot Tub Boat Victoria, a
company with distinctive floating
red tubs that are steered with a
rudder. The smell of smoke is in my
hair from the wood-fired stove that
heats the water. The perfect way to
experience Victoria, in my opinion. My
one complaint; I made a mess of the
charcuterie board on offer and ended
up with floating bits of cracker in the
water. Next time I might opt for a
fruit plate!

People line up for German Christmas treats from a food truck at the Esquimalt Farmers Market on a Thursday evening at Memorial Park. It's not quite like the winter markets you find in Europe (no "gluehwein" on offer, the customary hot spiced wine served at markets in the lead-up to Christmas), but it might be the closest equivalent! It is in walking distance for families living in the area who head home in the December darkness, lit up by suburban streetlights and a crescent moon.

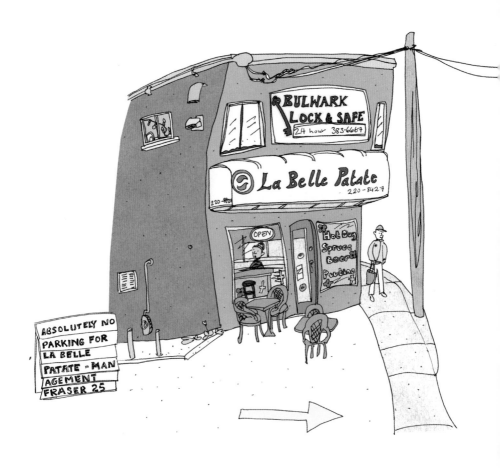

A place to enjoy Québécois fare like poutine and spruce beer (a sugary pop with notes of boreal forest), La Belle Patate obviously has numerous customers, based on a sign in front of the next-door convenience store stating:

"ABSOLUTELY NO PARKING FOR LA BELLE PATATE CUSTOMERS"

In early November, the eatery's front window commemorates soldiers lost during the war for Remembrance Day with red poppies and white crosses.

Fleming Beach is a popular rock-climbing spot, and a great starting point to explore Macaulay Point Park, an old military base turned walking trail. As I sketch, the sky is heavy and grey, but the air is alive with great smells after a big rain.

Not far from the floating homes on the wharfs of Esquimalt is this charming little home with a white picket fence at the corner of Gore and Lyall. I draw it because it looks like a place I might want to live someday. Behind me is a construction site for new condos with hoarding as a barrier, and kitty-corner is a barbed-wire fence marking the Canadian Forces base, where military families are housed. A man stops and tells me to check out "Jacob's house," an old seafarer's home, but I never manage to find it.

I stop along the Songhees Walkway to sketch the view toward Ogden Point across the harbour. As I get started, I doubt my proportions for a moment. Someone jogging behind me keeps a steady clip while sharing, "Your drawing looks amazing." Heartened, I continue, excited to add the endless blues of mountains and ocean and sharp green of the seaweed, and russet reds of the arbutus tree when it comes time to add colour on my computer at home.

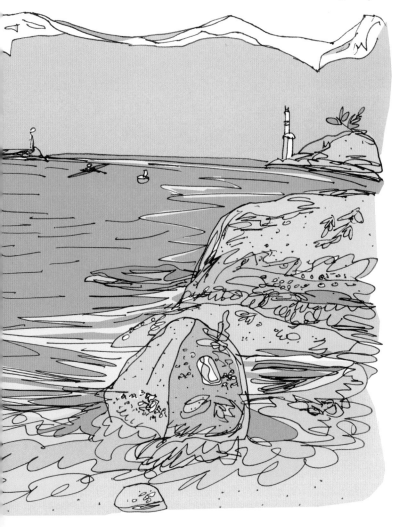

SAANICH, NORTH SAANICH & SIDNEY

If you need to get some perspective, you can head to Saanich and either hike Mount Doug (PKOLS as it was named by the Coast Salish people) or drive the winding road to its summit, where a panoramic view of the city, the Gulf Islands, and the Cascade and Olympic Mountains in the U.S. awaits. Picnic provisions can be procured on the way at the Root Cellar for farm-fresh produce or Fig Deli for authentic hummus, olives, baklava, and other Mediterranean delights.

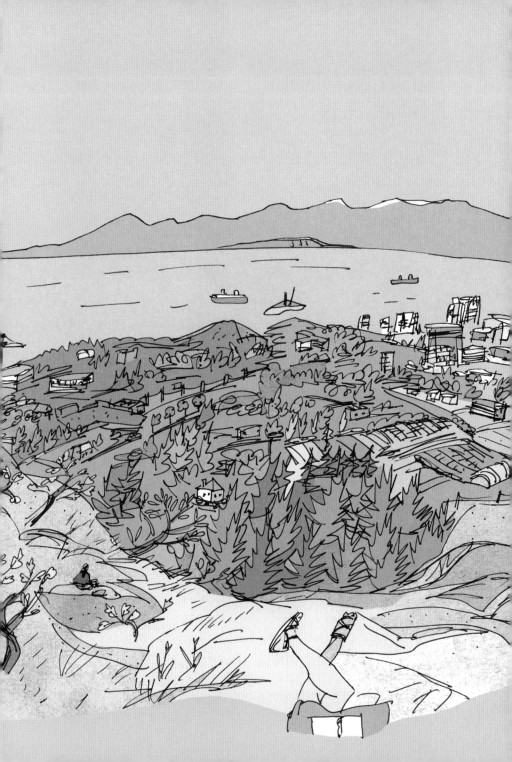

Despite having seen this very viewpoint of the Butchart Gardens on promotional material for years, it was not until I visited them that I learned that this site was once a limestone quarry, transformed by the vision of Jennie Butchart. She and her husband, Robert, moved to the land in 1904 to begin a cement business, and in 1912 as their lime supplies dwindled, they began the garden bit by bit using a horse and cart to bring in dirt, creating the impressive signature Sunken Garden.

Still owned and operated by the family, the Butchart Gardens now includes 22 hectares of multicoloured gardens, including a rose garden and a Japanese garden.

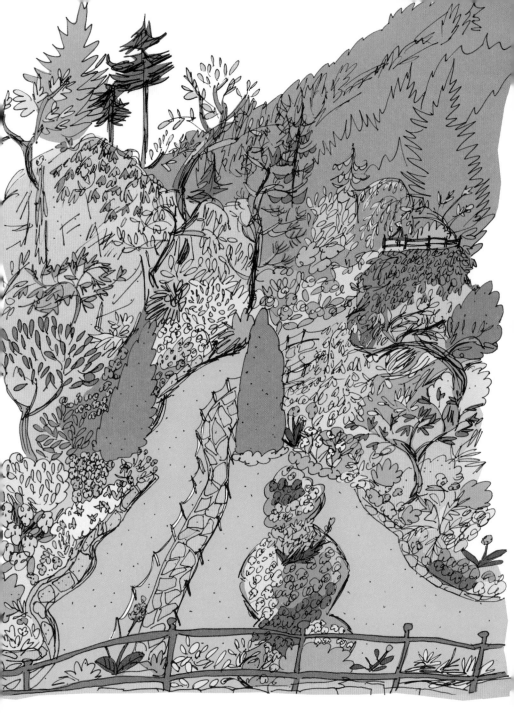

Not far from the Butchart Gardens, Keating Elementary is one of
thousands of schools in Canada that has its unique version of "dream fish"
swimming "upriver" on their property's chain link fence. The vision grew
from one citizen in Burnaby over on the mainland into the subsequent
formation of the Stream of Dreams Murals Society, which goes into schools
and asks kids questions to encourage connection to their local waters:

> Where is your local stream?
> Where does it come from?
> How do storm drains work?
> Where does your drinking water come from?
> What changes in behaviour can we all make to protect
> water and fish habitat?

Each student then paints their own dream fish, which is added to the
fence as a reminder of our shared responsibility to protect waterways.

Twig + Stone Botanical Medicine owner Rebecca Singer rents a garden plot a short drive from her city home in Fernwood, harvesting medicinal plants for her herbal practice. Yellow bursts of elecampane grow tall with blossoms that will be prepared into tinctures for soothing winter coughs, while immune-boosting echinacea flaunts purple petals. I feel grateful to have her products and counsel as a resource in my health toolkit.

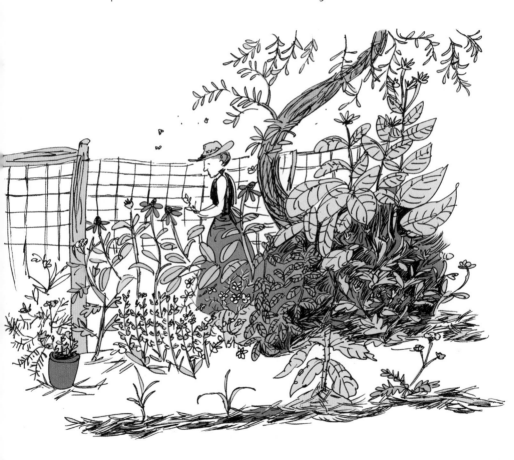

Pointed, shiny-leafed Oregon grape plants parade as festive holly after a snowfall at Swan Lake Christmas Hill Nature Sanctuary. A young family with Irish accents walks by, revelling in the crisp air.

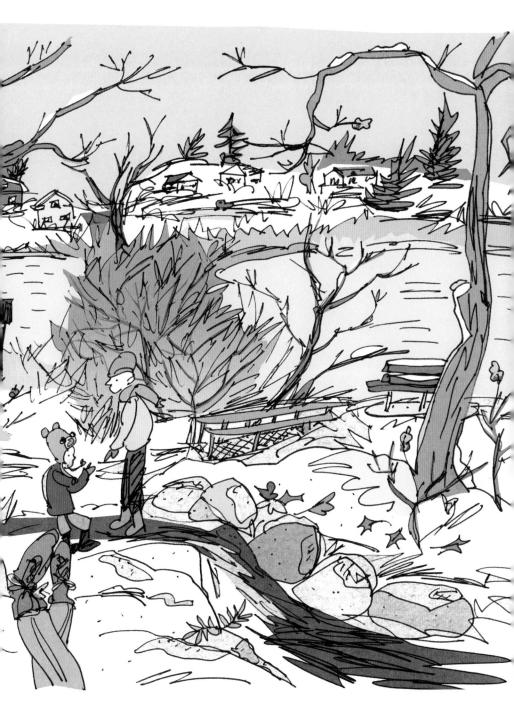

Established in 1870, Glamorgan Farm was named after a county in Wales that was the home to its early farmer Richard John. In 1913 a Victoria businessman named Sam Matson, owner of Victoria's Daily Colonist newspaper herded Jersey cattle here. The property still runs as a working farm with eleven log and wood-frame buildings with farm red roofs, creating a bucolic spring scene.

The Sandown Centre for Regenerative Agriculture is sandwiched between the original W̱SIḴEM (Tseycum) village called W̱SE,IḴEM, or Tsehum Harbour, on the east side of the peninsula, and the later village site on the west side, where the W̱SIḴEM community lives today.

I join an "ivy-pulling extravaganza" group to help remove invasive species from the forested parts of Sandown, a project that advertises itself as a place to fall wildly in love with our local food. What better place to recoup afterwards than at the nearby Fickle Fig Farm Market? Small planes land at the airstrip within sight of my table, creating the only noise on a quiet Sunday.

SIDNEY

Sea glass found on Glass Beach in
Sidney, famous for its shores of
smoothed coloured glass, can
become works of art with
some glue from the
nearby dollar store
and some creativity.

Satellite Fish Co. in Sidney has had three owners in sixty years. As I sketch an intriguing-looking door in the back corner of the shop, an employee says, "I'm gonna get you to move, otherwise I might get you with fish juice." Then, a little later, "Let me show you our winter wonderland," and he opens the heavy door that I had been sketching to reveal a whole ice-making room, at the ready for the season's first load of spot prawns coming in the following week. BC spot prawn season lasts six to eight weeks, typically from the middle of May to the end of June, and I can say from experience that they are delicious fried in butter with some garlic and lemon juice!

JUAN DE FUCA TRAIL

The pulse of ocean surf is met by the press of salal growing stubbornly toward the sea at Mystic Beach, where the eastern portion of the Juan de Fuca Trail begins. I am alone sketching the waterfall, until someone arrives, selfie stick in hand, to create a one-person photoshoot.

Selfie sticks aside, this is where I come to clear my mind more than once during my time in Victoria. I feel like the many beaches and trails and the vast wildness that feels close, even when in a bustling city, is a part of Victoria's makeup. I know not to take it for granted; the clear-cuts along the highway and ricocheting summer temperatures coupled with wildfires are a reminder that we live in a precarious balance and need nature more than it needs us.

When I hike back to my rented car to return to the city, a bear's gash on a tree commands respect. I feel fully alive, all senses awakened, and ready for whatever urban life may have in store for me. I am equally excited for when I can next return to the wild spaces that are so intrinsic and important to this place.

ACKNOWLEDGEMENTS

I have many people to thank for supporting me in the making of this book.

First of all, to my editor, Whitney Millar, for patience and energy, and to Rachel Brown for your initial input. To my publisher, Appetite: thank you, Robert and Lindsay for continuing to support my work, and all the minds and hands behind the scenes at Penguin Random House Canada, including the designer, Dylan Browne, marketing team, copy editor, and proofreader.

In Victoria, I give my thanks to all the farmers and vendors at the Moss Street Farmers Market for keeping me nourished and particularly to Eddy and Kristin for your dedication to sharing the stories of residential school survivors every week. Thanks to Lauren and the Chang and Wong families for sharing their experience. To Cathy at Sorensen Books for a treasure trove of books and encouragement. Thanks to Dwane at Zeitgeist Vintage Store who furnished me with a desk and stool, and Raphael and Richard for the trundle bed that made my tiny Jewel Box apartment functional, and to Mikal and Lisa for holding off on renovations just long enough for me to be their tenant.

My sincere appreciation to Sarah R, Evan, Sarah F, Pete, Leanna, Brian, and their respective little ones for garden visits, bike rides, and community. Laurie for writing sessions and walks, and Alex for dancing, and the whole SEDA community—it was so much fun to dance again. Jen, it was great to connect with someone who knows my Halifax life and is also making art. Bora, thanks for your visit and willingness to go on an adventure. Thank you, Rebecca and Tracy, for your healing abilities. Jeremy, I enjoyed seeing your art firsthand. Thanks to Ineke and her little treehouse in Shirley for spacious time away from the city. Thanks

to Cheryl, for sharing knowledge. Thanks to Chickweed at Eden Grove for showing me around camp. To Joy at Rock Bay Studios for helping me find a place to spread out. Thanks to the staff at Island Blue, especially David and Gavin, for patience and helping me keep my little business going. The use of space at Swan Lake's Nature House gave me a place to focus on writing. Thanks to Donovan and Barclay for my time at the Ou Gallery residency in Duncan. To Michelle, for reconnecting all these years later, during a pandemic, no less. Thanks, as always, Tessa and Mark. To anyone I have forgotten, my apologies, and thanks!

Finally, a big thank you to my family. To my mum, Trish, for coming over and helping me. To my dad, Mark, and stepmother, Celine, and stepbrothers, Lou Lou and Charles, for memorable visits. To my siblings and their partners, Laura and Stefan, for bringing Hannah over, and to David and Nicole, and Jeff and Patricia, for frequent Zoom calls and warm hospitality when I could make it to the mainland. Thanks to Hannah for bringing us so much joy. We went through a very difficult year, and I am grateful, finally, to my own process of drawing and exploring that helped me make some sense of my world, and for all the beauty that I found in Victoria.

Appetite by Random House® and colophon are registered trademarks
of Penguin Random House LLC.

Library and Archives Canada Cataloguing in
Publication is available upon request.
ISBN: 978-0-525-61104-2
eBook ISBN: 978-0-525-61105-9

Illustrations by Emma FitzGerald
Book and cover design by Dylan Browne
Printed in China

Published in Canada by Appetite by Random House®,
a division of Penguin Random House Canada Limited

www.penguinrandomhouse.ca

10 9 8 7 6 5 4 3 2 1

appetite Penguin
by RANDOM HOUSE Random House
Canada

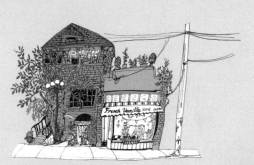

Jubilee

Downtown

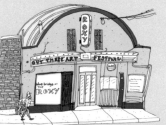

Fernwood

Quadra Village

Chinatown

Rockland

James Bay